IMAGES
of America

VILLAGE OF
MONTGOMERY

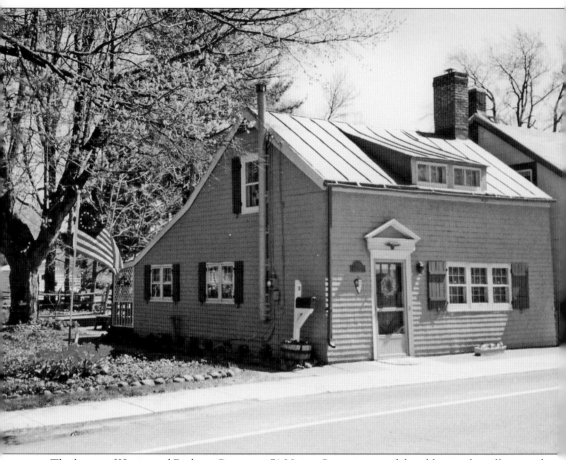

The house of Kevin and Barbara Conroy at 71 Union Street is one of the oldest in the village, and it is the oldest house that is not located on its original site. Dating from the 18th century, it was originally called Mary Smith's Tavern (she was also known as the widow Smith), and was located in the vicinity of the Wallkill River Bridge. The first village board meeting was held here on March 6, 1810, after the village was officially incorporated on February 17, 1810. The fire company was also founded at that first meeting. (Photograph courtesy of Kevin and Barbara Conroy.)

ON THE COVER: This view of Ward Street (Route 17K) dates from the early 1900s and shows the firemen's parade. The large three-story building in the distance was Daniel A. Shafer's Wallkill Hotel, which was a focal point of village life years ago. Shafer, known for his clambakes and production of apple brandy, served as village president in 1888. The hotel was removed in 1956. (Photograph courtesy of Robert L. Williams.)

IMAGES
of America

VILLAGE OF
MONTGOMERY

Robert L. Williams, Marc Newman,
and Mayor Stephen Brescia

ARCADIA
PUBLISHING

Published by Arcadia Publishing
Charleston SC, Chicago IL, Portsmouth NH, San Francisco CA

Printed in the United States of America

Library of Congress Control Number: 2009942413

For all general information contact Arcadia Publishing at:
Telephone 843-853-2070
Fax 843-853-0044
E-mail sales@arcadiapublishing.com
For customer service and orders:
Toll-Free 1-888-313-2665

Visit us on the Internet at www.arcadiapublishing.com

In loving memory of Vince Brescia,
Bernard Newman, and Robert J. Williams

CONTENTS

ACKNOWLEDGMENTS

The authors, along with the governing body of the Village of Montgomery, wish to express their sincere thanks to Darlene Andolsek, Nan Beatty, Jai Benson, Dominic and Judy Bonasio, Skip Chambers, Barbara and Kevin Conroy, Carol Daley, Phil DeLessio, Joe Devine, Ed Devitt, Nancy Bettcher Dooley, Ray Gillespie, Gertrude Greene, Mary Havens, Carolyn Henrie, Greg Kaufmann, Nancy Michaels, Montgomery Fire Department, Brenda Newman, Rev. Brian Randazzo, Howard Reis, Veronica Rickerd, Larry Shafer, JoAnn Scheels, Nina and Steve Snyder, Stacy Brescia Spreer, Monserrate Stanley, Jim and Johanna Sweikata, Linda Thompson, Robert Wiggins, Marion Wild, Roger Wild, Charlie Wille, and Mary Van Dyke for their knowledge and use of their irreplaceable photographs. Without them, this effort would not have succeeded. In addition, the authors would like to thank those who have individually shared with them their stories and knowledge of the village over the years and are not among us today: Gladys Shafer A'Brial, Olive Burnett, Dave Burnett, Gertrude Cahill, Lemma Crabtree, Virginia Shafer Donnelly, Madeline Shafer Earle, Bob Eurich, Bo Gill, Anna Hanlon, Agnes Karsten, and Dorothy Rudolph. Thank you all for the role you played in making this overview of the village's history possible.

INTRODUCTION

The history of the village of Montgomery dates from the 18th century. Its early history is interwoven with part of the beginning and the end of the American Revolutionary War. This is where the story begins. Each year the village hosts General Montgomery Day in honor of its namesake, Gen. Richard Montgomery. In the midst of the bicentennial of the village, we offer a book filled with memorable photographs and a unique history.

The book begins with the settlement of Ward's Bridge, later renamed by soldiers who fought with Gen. Richard Montgomery in 1775 during the invasion of Canada. In the Brick (Dutch) Reformed Church graveyard are the remains of some of these patriots with their headstones. The book pays tribute to these men and General Montgomery, the first general killed in the Revolutionary War. The book highlights involvement in the war, such as Montgomery resident John Van Arsdale, who was released from a British prison ship. He climbed a large mast near the East River to hoist down the British Union Jack as Sir Henry Clinton's British ships and army set sail for Britain in 1783. Less than a century earlier, the village was settled by British, German, and Dutch settlers.

The early schools and churches are profiled in the book: Presbyterian, Methodist, Dutch Reformed, Church of St. Andrews, and Roman Catholic. Education was emphasized in the village with the construction of a small school and, later, the academy building, which was the fourth oldest educational system in the state of New York, incorporated in 1792. The development of a school system, from the one-house school to the centralized school system that exists today, is discussed in the book.

One of the most important chapters and episodes in the book covers the fires that took place in the village and the determination of its residents to build a new firehouse in 1913 following the fire of that year. Three fires had taken a toll on the people of the village, and, in each case, they rebuilt and recruited more members to serve on two fire companies. The Orange County Firefighters' Museum and its fire engines from the early 19th century mark this determination and respect for the men and women who have served these companies for two centuries.

There were numerous businesses that developed in the village since the early 18th century. A gristmill was one of the early businesses, followed by textile mills and worsted yarn mills. In the 1880s, two of the early business founders, William Crabtree and Arthur Patchett, produced worsted yarn. Many of the photographs utilized in this book are from the exclusive collection of the William Crabtree family.

The dedication to duty and service for the nation was continued by family members in the 1860s, when some of the male residents joined the 124th Regiment in the Union army, known as the "Orange Blossoms," who distinguished themselves during several major battles of the war, such as Chancellorsville. This dedication to service continued in the Great War and World War II.

Montgomery has several historic sites and districts that have markers to commemorate their importance and registry with the federal government and the state of New York, including the

John Crabtree House, Patchett Homestead, Montgomery Worsted Yarn Mills, and Montgomery House. The architectural styles of these historic homes reflect the Federal, Greek Revival, and Victorian eras. There were numerous businesses and buildings within the main areas of Union Street and Clinton Street.

One of the major historic sites is the old National Hotel. During the 1920s and 1930s, the famous and the infamous spent a night at the hotel on their way back to Newburgh or upstate to the Catskills. Route 17K, originally known as the Newburgh-Cochecton Turnpike, would bring travelers into the village of Montgomery directly from the city of Newburgh. When bootleggers such as Legs Diamond and Al Capone were running Canadian whiskey down the Hudson River, they would park their speedboats along one of the coves at Newburgh and have a car waiting to take them into Montgomery. Early the next morning, you could find Al Capone and Frank Nitti sitting outside the hotel having breakfast. They were getting ready to return to Newburgh to continue bringing the liquor down to New York City to such business acquaintances as Dutch Schultz. Another famous visitor was Babe Ruth, who would leave Yankee Stadium for the weekend to be with his first wife and daughter at his summer home, a farm in the Catskills.

This book has nine chapters that bring the reader up to date with photographs and information about the General Montgomery Day Parade and Festival. For 20 years, this family-day affair and outing has become the largest small-town parade in all of New York state. With almost 3,000 people in the parade, it marches from the Orange County Airport, on the outskirts of the village, to Clinton Street amidst a wave of 25,000–30,000 people.

This book is not meant to be a complete history, but rather a sampling of the rich and diverse history of the village. It is also intended to be a timeless tribute to her residents of yesterday, today, and tomorrow. It is our hope that this book will be cherished by present and future residents of the area and will enlighten all of the proud historical background of the village.

One

EARLY HISTORY

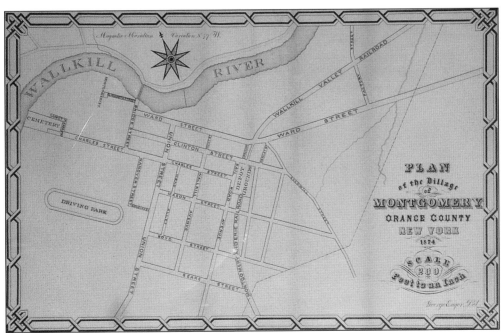

One of the earliest tracts of land in the village of Montgomery was settled by Jeronimous Weller, Johannes Mingus, Jeronimous Mingus, and Mathias Miltzbagh on 10,000 acres. Johannes Mingus and Jeronimous Mingus built a mill on the east side of the Wallkill River. This was the beginning of businesses in the village: gristmills for flour and grain production. (Photograph courtesy of Marc Newman.)

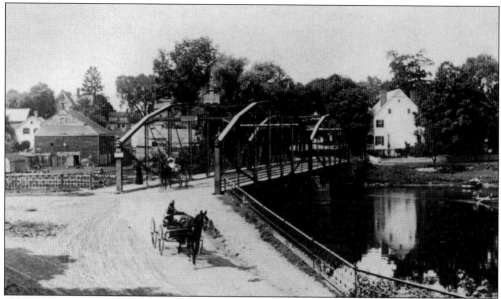

When James Ward decided to build a mill near the Mingus Mill, the area became a magnet for German and Dutch settlers. The Mingus Mill was later purchased by James Ward, who built a bridge to cross the Wallkill River, connecting points east and west. As a result of the importance of the bridge, the area became known as Ward's Bridge. (Photograph courtesy of Robert L. Williams.)

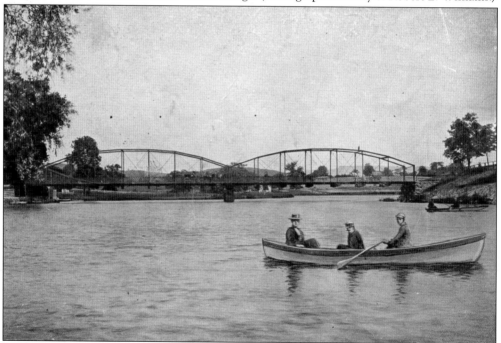

The current Ward's Bridge was constructed in the 1940s with a small sidewalk for pedestrians. The roadway has two lanes with one east and the other west. Carriages and coaches made use of the earlier bridges for passenger, freight, and postal service. The bridge would make travel and shipments from one county to the other much easier. (Photograph courtesy of the Village of Montgomery Museum.)

10

The Mingus-Ward Mill was the first successful business in the village. The gristmill ground grain into flour. Gristmills used the power of the water current to turn a waterwheel. A sluice gate opened a channel that would allow all the water to push against a paddle wheel or waterwheel, which was mounted vertically or sometimes horizontally. (Photograph courtesy of Marc Newman.)

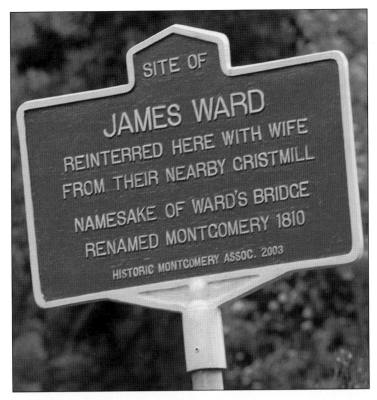

Aside from the Mingus Mill and the Ward Mill, there was the Crist Mill. William Sharpus had acquired 542 acres, which was purchased by Henry Crist, Stevanus Crist, and Mathias Mitzpatch in 1783. A mill was built south of the Mingus Mill on the west side of the Wallkill River. The Crist Mill contained approximately 200 acres. Jacob Crist, son of Henry Crist, built the mill. (Photograph courtesy of Robert L. Williams.)

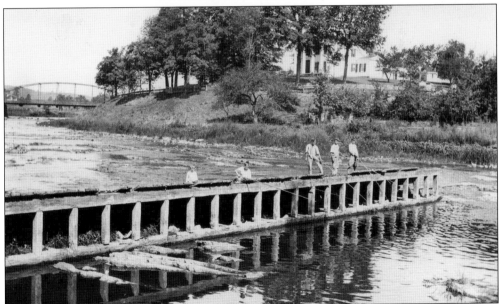

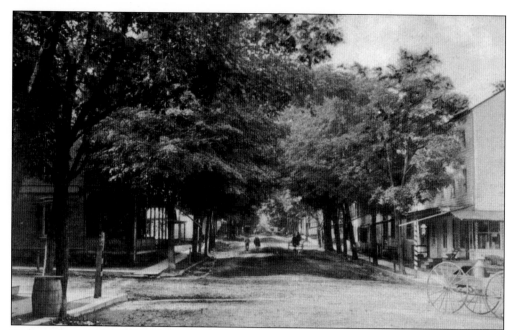

Early residents such as John McFaught, John McKinstrey, Matthew Hunter, Samuel Smith, Arthur Parks, Oolis Shulp, John McGarrow, George Everson, and Mahar Wigton settled with James Ward and David Crist on village land. Local medical practitioners Charles and Alexander Clinton became residents. James Clinton, son of Alexander, was a surveyor and had a practice in Little Britain. He drew the plans for the streets of the village. (Photograph courtesy of Nancy Dooley.)

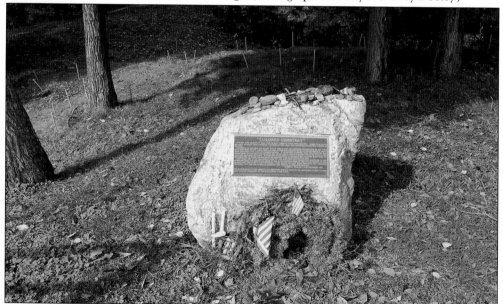

Members of the farming community brought black indentured servants to the village, and later, slavery became institutionalized. In Orange County, there were 310 slaves by 1746 compared to 1,122 slaves in Ulster County that same year. Of the 3,000 people who lived in Orange County at the time, the slave population was approximately 10 percent. The terms of black servitude gradually increased from 7 years to 11 years or more. (Photograph courtesy of Marc Newman.)

By 1710, slavery was institutionalized in New York, and the number of slaves increased between 1710 and 1750. In the village of Montgomery, Dutch, German, and English settlers with large tracts of land purchased black indentured servants to work on farms. On the outskirts of the village, along the west side of Route 416, Montgomery's "Colored Cemetery" can be found. In New York state, slavery was finally prohibited by the 1820s. (Photograph courtesy of Marc Newman.)

With the approach of the Revolutionary War, volunteers were raised in Orange, Ulster, and Dutchess Counties. One such individual was Arthur Parks, who was an officer during the war and later became a member of the Provincial Congress of New York. He helped create the New York state government. He was a member of the New York State Convention in Kingston around 1777, which drafted the first constitution of the State of New York. (Photograph courtesy of Marc Newman.)

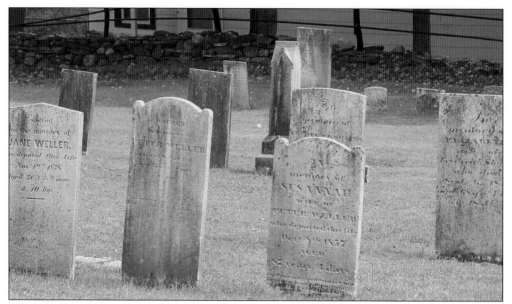

John Van Arsdale was a prisoner of war of the British in New York City until the British evacuation in 1783. Sir Henry Clinton, commander of British forces, released all American prisoners but left the British Union Jack flag on the largest flagpole. John Van Arsdale climbed to the top and ripped off the British flag to the cheers of thousands of citizens. Both of these pictures were taken in the Brick Church cemetery, where Van Arsdale is buried. (Photograph courtesy of Marc Newman.)

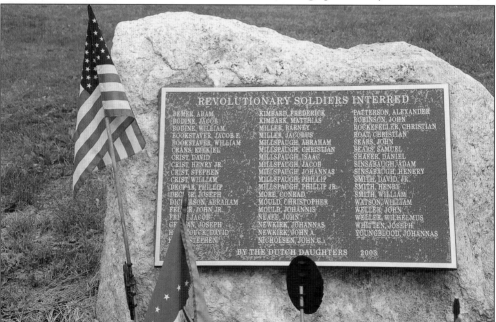

In the years that followed the war, the village was known as Ward's Bridge. The district was divided into two sections: the Wallkill Precinct and the Hanover Precinct. At a town meeting at Stephen Crist's home, the Hanover Precinct was renamed the Montgomery Precinct; it was later called Montgomery. The village changed its name from Ward's Bridge to Montgomery when a postmaster renamed the town. (Photograph courtesy of Marc Newman.)

After the Revolutionary War, veterans who served with Gen. Richard Montgomery from Dutchess County migrated to Orange County. Gen. Richard Montgomery led the Northern Army in its invasion of the British fortifications from the Champlain Valley to Quebec. From September to November 1775, his army was very successful in taking control of Fort St. John, Fort Chambly, and the city of Montreal. General Montgomery was killed leading the assault into the city of Quebec. (Photograph courtesy of Marc Newman.)

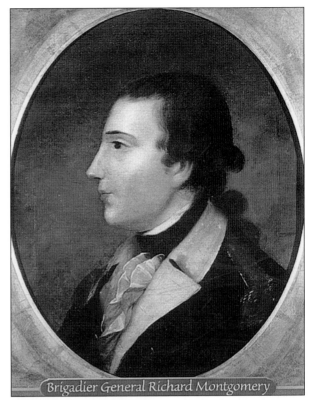

Brigadier General Richard Montgomery

Those Revolutionary War veterans who settled in Montgomery and Germantown felt the town and the village would be appropriately named Montgomery, after the first high-ranking American officer killed in the war. Numerous veterans are buried in the Brick Church Cemetery with markers from the Daughters of the American Revolution. After 1776, there were four regiments created in Ulster County. The 2nd Ulster Regiment included volunteers from New Windsor and Hanover Precincts. (Photograph courtesy of Marc Newman.)

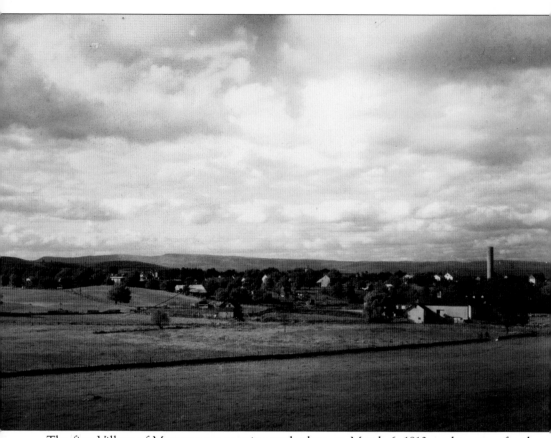

The first Village of Montgomery meeting took place on March 6, 1810, and trustees for the village were elected: Hugh Lindsay, Thomas McNear, Benjamin Sears, John Misser, and Reuben Neely. At the same time, three fire wardens were appointed: Joseph Conklin, Walter Mead, and Joseph Nicholson. The slow development of a fire company, and later a fire department, became one of the most important and essential developments by the "Village Elders" in trying to meet the needs of its residents and their protection. (Photograph courtesy of Robert L. Williams, Crabtree collection.)

Two

CHURCHES, CEMETERIES, AND SCHOOLS

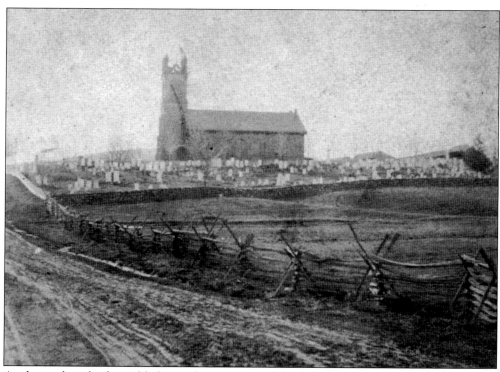

As the settlers slowly trickled into the area, one of the first things they established was their houses of worship in addition to setting aside land to bury their dead. The initial meetinghouses were established on lands outside the village. Among the first was the Dutch Reformed Church on Route 17K. Organized in 1732, the present building (1858) is the fourth to have stood on the property. (Photograph courtesy of the Village of Montgomery Museum.)

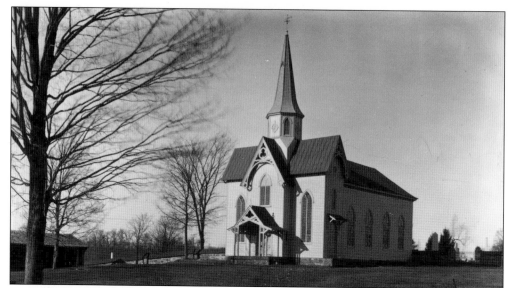

Goodwill Church is the oldest standing church building in the area. Dating from 1767, it was remodeled in 1871, bringing it to its current appearance. As with the Dutch Reformed Church, many village residents throughout Montgomery's history have attended this place. What makes this building unique is that it binds many generations together extending back to beyond the establishment of the village and nation. (Photograph courtesy of Robert L. Williams, Crabtree collection.)

The log Hebron Lutheran Church and Germantown Cemetery were established early in the 18th century at the intersection of Routes 211 and 416. It fell out of use prior to the American Revolution, and the building slowly vanished, but the graveyard survives. Listed on the State and National Registers of Historic Places, the site contains many crude pioneer gravestones. Dederick Shafer, progenitor of the Shafer family, is noted to be buried there. (Photograph courtesy of Robert L. Williams.)

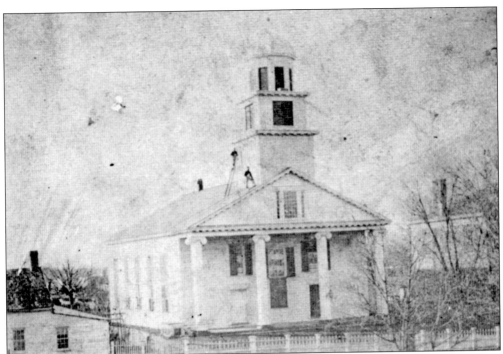

The Methodists and the Presbyterians were the first to establish themselves in the village; their churches were of the Greek Revival style. Early on, the interior plaster walls of the Presbyterian church were finished with a trompe l'oeil artwork, which created the illusion of three-dimensional architectural details. This photograph of the Presbyterian church dates from 1870. (Photograph courtesy of the Village of Montgomery Museum.)

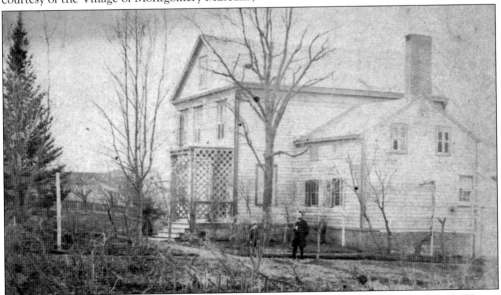

The old Presbyterian manse still serves its original intended purpose and is located at 100 Union Street. Built in the Greek Revival style, the building was prefabricated in Newburgh and brought to the village about 1842. During that same year, a house was put together here and sent to Newburgh. (Photograph courtesy of the Village of Montgomery Museum.)

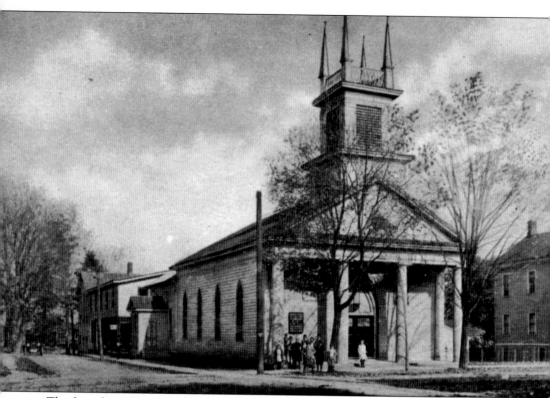

The formal organization of Montgomery's Methodist congregation took place in 1829. A small church was built that year and the parsonage four years later (located at 156 Clinton Street). The current church edifice appears to be of later design and was probably built about 1840. Some interior finishes, including the pressed-tin siding on the upper portions of the walls, date from the early 20th century. Due to decreasing membership, the Methodists merged with the Presbyterians in the early 1970s, and the Methodist church was donated to the village. The building today serves as the Village Museum. (Photograph courtesy of Robert L. Williams.)

Montgomery's Catholics have a long and proud heritage extending back into the late 18th century, and it is recorded that early masses were held at the residence of Dr. Whalen, a short distance outside the village (on the vacant lot at the juncture of Route 17K and Albany Post Road). Fr. Hugh O'Hare arrived in the village around 1864 to form a parish. Four years later, the current brick building was constructed on Union Street. Some recall the ornate-patterned, slate-shingled roof that had the wording "Sancta Maria" patterned into its design. This turn-of-the-century view was taken before the tower and stained glass windows were added about 1913. The interior, as it originally appeared, included the trompe l'oeil finish on the wall behind the decorative altar. (Photographs courtesy of Robert L. Williams.)

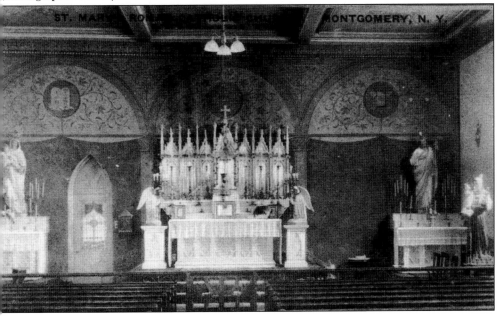

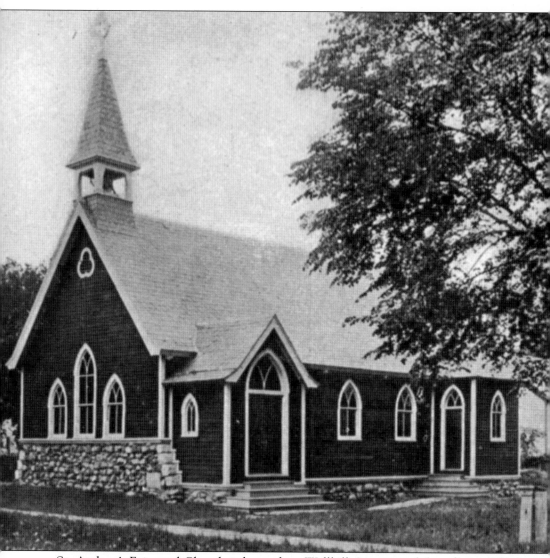

St. Andrew's Episcopal Church is located on Wallkill Avenue and dates from 1903. It was established by Reverend Lewis as a mission of the church in Walden and remained a mission until 1955, when it became self-sustaining. A carriage block and hitching post once stood along the sidewalk—familiar objects at the beginning of the 20th century. To the rear of the building, the Boyd Street School can be seen. To the left is the present Devitt House, originally the Hart Homestead, which stood on Union Street and was moved about 1890, when the Quackenbos' place was built. (Photograph courtesy of the Village of Montgomery Museum.)

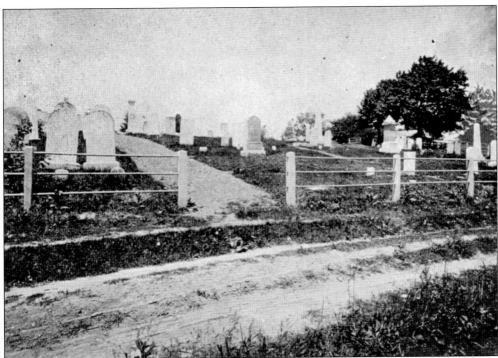

The village contains two cemeteries: Riverside Cemetery, dating from the first half of the 19th century, and St. Mary's, dating from the second half of the 19th century. Earlier burials would take place at one of the graveyards on the outskirts of the village: Brick Church, Goodwill, Germantown, or the "Colored" Cemetery. A walk today through either of these village graveyards provides a who's who in village history. Names such as Shafer, Brescia, Eager, Senior, Bull, and Stratton are displayed, and the styles of their markers generally attest to their prosperity in life. The rear portion of the Riverside Cemetery along the Wallkill contained a section for those of African American decent, thus exhibiting the class structure that existed at that time. Undoubtedly some of these folks were former slaves. (Photographs courtesy of Village of Montgomery Museum.)

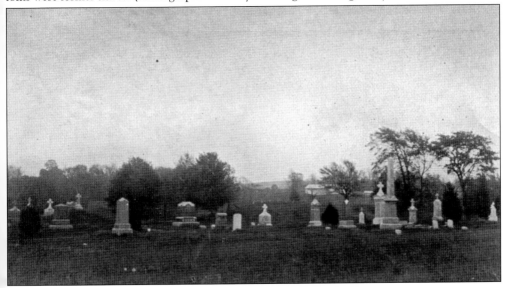

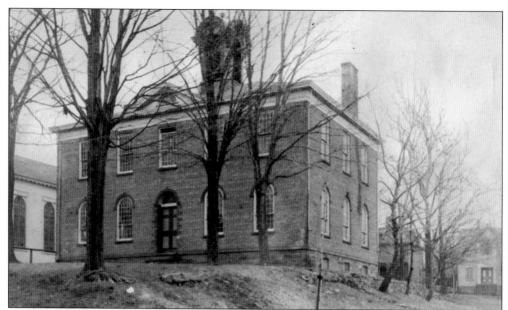

Organized in 1787 and incorporated four years later, the Montgomery Academy is one of the oldest academies in New York state. The Federal-style brick building that is known and loved as Village Hall was constructed in 1818 at a cost of $5,499.50. The above photograph, dating from 1890, shows the building before the west addition was built, shortly after the turn of the century. (Photograph courtesy of the Village of Montgomery Museum.)

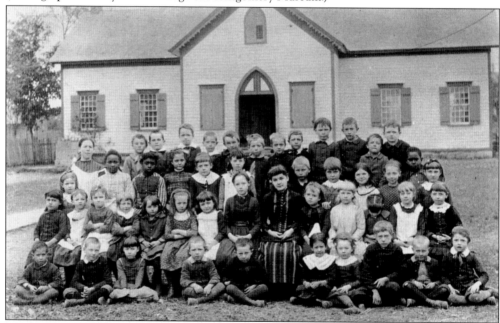

The Boyd Street District School stood on the north side of Boyd Street between Mead Alley and Wallkill Avenue. Most likely dating from the late 1830s, it was a free public school as opposed to the academy, which was tuition-based. In later years, it was used by the Security Reliner Company for vulcanizing. A residence now stands in the vicinity of the old building. (Photograph courtesy of the Village of Montgomery Museum.)

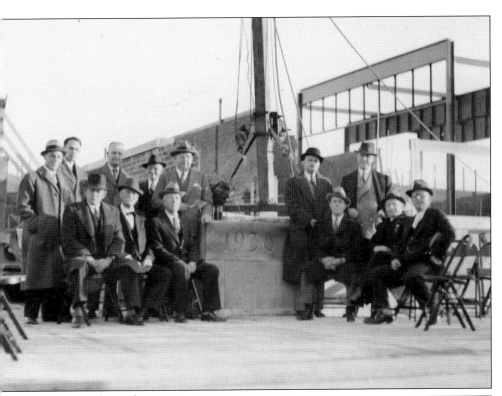

The above picture shows the cornerstone ceremony for Montgomery High School in 1936. Ed Devitt (F. Edwards's grandfather), seated second from right, was instrumental in spearheading this project. The property was bought as part of the McMurtrie Farm, and Dayton McMurtrie was Devitt's son-in-law. Once the property was acquired, Ed Devitt used his influence with the Roosevelt administration to get WPA funds to commence the project. Being one of the sole Democrats in the area certainly did not hurt. School board president Dan Taft, standing left of cornerstone, and school board members Aldolphus Suydam (seated left of Devitt) and George Havens (seated right of Devitt) were on hand for the momentous occasion. The picture at right shows a few unidentified gentlemen raising a toast to the new school. (Photographs courtesy of Ed Devitt.)

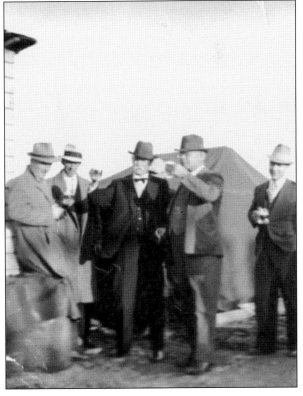

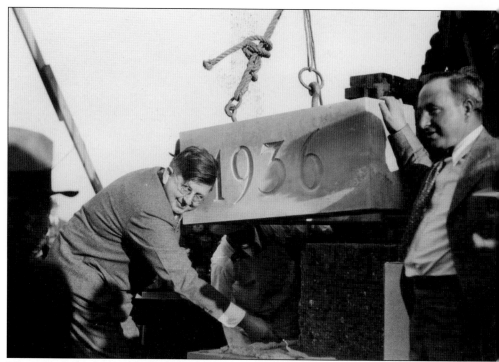

The new school was constructed to alleviate overcrowding at the academy, present-day Village Hall The cornerstone is shown here being set with Dan Taft posing (left), and the architect (right). A more space was needed for grades 1 through 12, the new project made it more affordable for District Seven, otherwise known as the Village School. (Photograph courtesy of Mary Havens.)

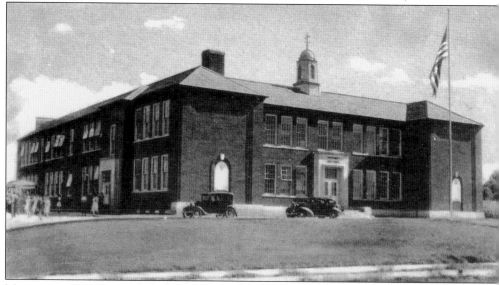

Montgomery High School had a complete metal and wood shop, cafeteria, home economics classes, science lab stations, and a dual-purpose gymnasium and assembly hall—something unheard of at that time. In 1958, the Town of Montgomery Central School District was created. This resulted in the building of Valley Central School on the former Muller Farm on the south side of Route 17K, a short distance to the east of the village. (Photograph courtesy of Robert L. Williams.)

Three

FIREFIGHTERS AND FIRE DEPARTMENT

The tradition of firefighting dates back to the 18th century, well before the incorporation of the village. Firefighting had its early roots in ancient Rome. Bucket brigades were created during the time of Emperor Nero. Usually the mass numbers of firefighters were Roman slaves. Buckets were carried by slaves to the location of the fire, with directions given by the owner of the household. (Photograph courtesy of Marc Newman.)

In 1648, Dutch governor Peter Stuyvesant of New Netherland (New York state) created a fire warden board. This board was made up of four men who were appointed by the governor and reported directly to him. They were responsible for the inspection of all chimneys and roofs. Specific dimensions and guidelines were established, and violators were given fines. (Photograph courtesy of Carol Daley.)

Another fire-prevention group that the New York Dutch established were the "Prowlers" or "Rattlers." There were approximately eight men in number, and their job was to patrol the streets of New York with large rattles or noisemakers. If a fire had broken out, they would quickly twist and shake their rattles to alert the neighborhood to immediately prepare its bucket brigade. (Photograph courtesy of Robert L. Williams.)

When the English settlers arrived in Jamestown in 1607 and quickly established their stockade in defense against the Powhatan Indians, they were ill prepared for the outbreak of fires. A fire broke out in 1608 that destroyed most of the stockade and compound. Maybe Capt. John Smith was right when he felt the settlers would be much safer to live outside their stockade near the Powhatan Indians. (Photograph courtesy of the Village of Montgomery Museum.)

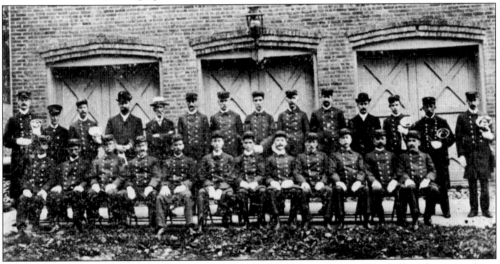

Meanwhile, in the north, Gov. Jonathan Winthrop of the Massachusetts Bay Colony began making fire protection preparations. Early homes in Massachusetts Bay had traditional wooden chimneys and thatched roofs in the 1630s. In 1666, the Great Fire of London destroyed hundreds of buildings, almost 100 churches, and thousands of homes. This became the catalyst for the creation of the English Bucket Brigade. The original Village of Montgomery Fire House and its fire company are pictured in the 1890s or early 1900s. (Photograph courtesy of the Village of Montgomery Museum.)

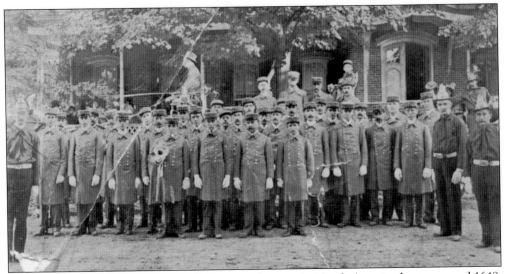

The tradition of volunteers forming lines to put fires out in North America began around 1648. Early buckets in the colonies, including those used in the village of Montgomery, were made of leather with a metal hoop woven into the top for support. These large buckets had rope handles and were lined to prevent any loss of water. Usually a tanner or cobbler (shoemaker) made these buckets on consignment for the residents or the village at large. The Village of Montgomery Hook and Ladder Fire Company is pictured here in front of the Palace Hotel, otherwise known as the Community House, in the 1890s. (Photograph courtesy of Gertrude Greene.)

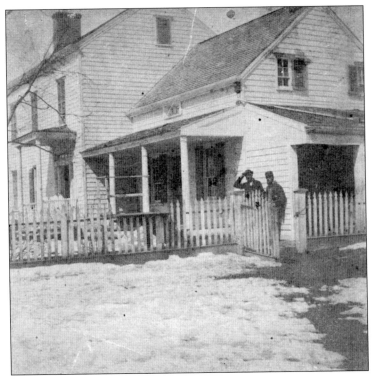

Many homes were made of clapboard in Colonial America. The use of clapboard and its construction for housing dates back to the 1630s. Clapboard was strips of wood that were attached to the outside walls of homes. One edge on the board was usually trimmed to be slightly thinner than the other. The boards were attached horizontally to wooden studs. Woods such as spruce and pine were used as clapboards. (Photograph courtesy of the Village of Montgomery Museum.)

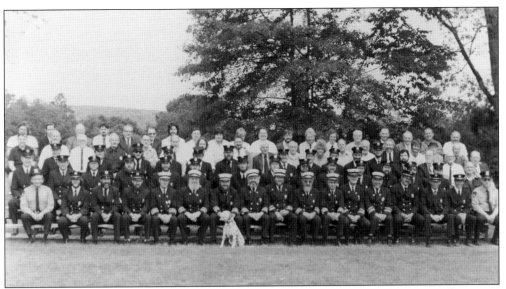

Volunteers for fire companies, including the bucket brigades, came from all classes in 18th-century America regardless of income. Even George Washington was a volunteer firefighter in Alexandria, Virginia. In 1774, he was instrumental in purchasing a hand pumper for his fire company, the Friendship Veterans' Fire Engine Company. Benjamin Franklin urged men to form fire companies and bucket brigades. The tradition continues into the 21st century. This picture was taken at Veteran's Memorial Park and in 1976, when Vince Brescia was fire chief. It was before a parade celebrating the county's bicentennial, which was held in the village. Many of the firemen grew beards, which was a tradition for such big celebrations. The picture shows the entire department, both Fleets Hook and Ladder Company and the Wallkill Engine and Hose Company. (Photograph courtesy of the Village of Montgomery Fire Department.)

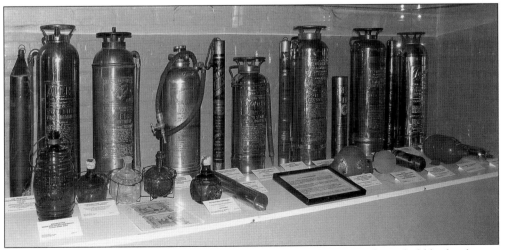

Village trustees ordered the purchase of fire buckets and ladders. Every household had to have a bucket filled with water at the front door. These village leather buckets held about two gallons of water. Another type of fire extinguisher was the glass ball or "grenade," usually filled with tetrachloride. On the "Red Comet" grenades was a special grip with a spring-loaded trigger. (Photograph courtesy of Carol Daley.)

The village had several different sources of water. One source was barrels and tubs that were filled with water collected from the roofs as a result of heavy rain. A second source was cisterns that were built for reserves of water and were located in several areas near or on Clinton and Union Streets. Another source of water was the Wallkill River itself on Ward Street. (Photograph courtesy of Robert L. Williams, Crabtree collection.)

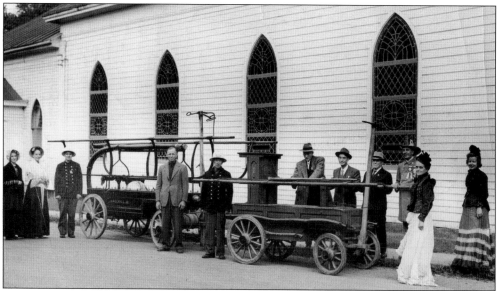

The first fire company was known as Independent Company No. 1. The members of that company in 1816 were Daniel M. Frye, Charles Borland Jr., Joshua Conger, David Strachan, Abraham Hunter, Elnathan Sears, Isaac Jennings, Stephen Preston, Walter Mead, Samuel W. Eager, Thomas Goldsmith, John James Millspaugh, Francis Fowler, Harvey Stanborough, and Jeremiah Scott. An early tool of these firemen was the pike-head fire ax. Residents are pictured with the early "hand pumpers" of the village of Montgomery outside the Methodist church. (Photograph courtesy of the Village of Montgomery Museum.)

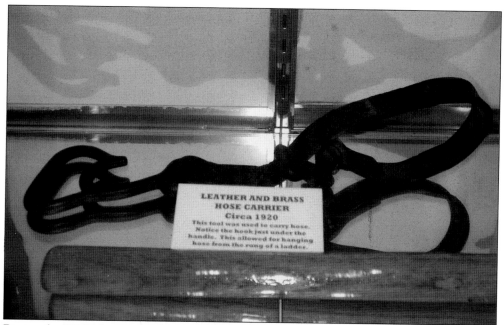

During the 1800s, firemen used hose carriers, which were made of leather and brass. Hose jackets were carried to a fire in case the water hose broke or was leaking. A sleeve was placed around the break line. This would permit the continued use of the hose; thus, the time to connect a new hose was avoided. (Photograph courtesy of Marc Newman.)

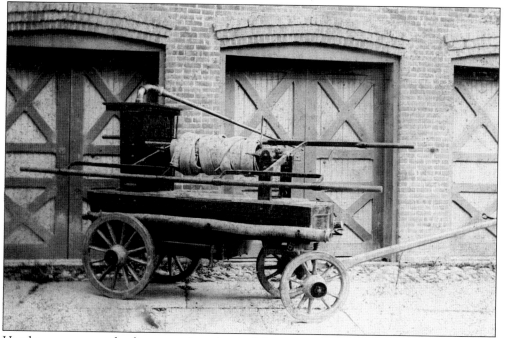

Hand pumpers were the first type of mechanized fire apparatus. These pumpers were pulled by more than half a dozen men to the fire. Volunteers would pump the handles up and down on both sides. As one side was pushing down, the other side would grab the top bar and push it down in a seesaw configuration. (Photograph courtesy of the Orange County Firefighters Museum.)

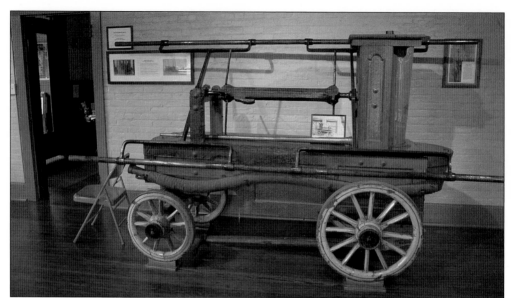

The Village of Montgomery purchased the first hand engine from Kingston, New York. The cost of the machine was $699. To supervise the bucket brigade, fire wardens were appointed to visit every home to see that the hearths, chimneys, stoves, and other devices were in full working order and in clean, safe condition. Each house, by code, had to have a leather fire bucket, which would be on the front sidewalk. (Photograph courtesy of Marc Newman.)

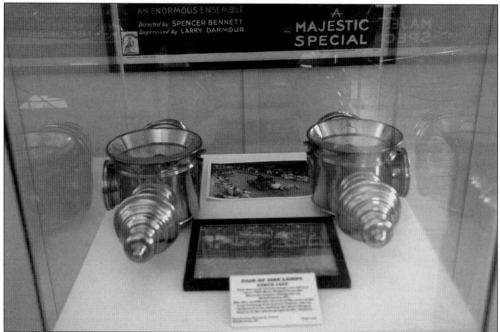

Eventually lanterns were placed on the pumpers in order to illuminate the area around the fire pumper. The Dietz Lantern Company created a special lantern referred to as the "Fire King." These lanterns appeared on the front and rear of the wagon or carriage. They were usually made of brass, copper, or steel with a guard or shield at the top that protected the lantern from water spray. (Photograph courtesy of Marc Newman.)

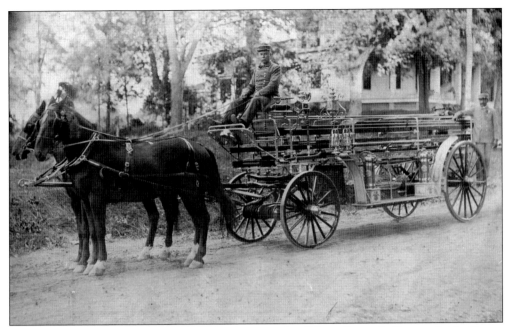

In 1840, the first of several fires broke out on the west side of Union Street, halfway to Bridge Street. Two years later, an amendment was added to the village charter that ordered the creation of a hook-and-ladder fire company. Included was the creation of a firehouse and inspections of all fireplaces, chimneys, cisterns, wells, and water supplies. In 1845, another fire broke out that destroyed the east side of Union Street. (Photograph courtesy of the Village of Montgomery Museum.)

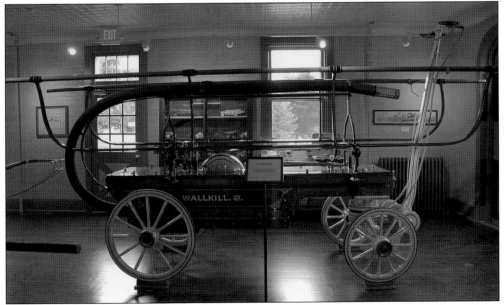

By 1850, the first firehouse, which was a wooden structure, was built adjacent to the academy building. By 1860, a second hand pumper was purchased, and a new fire company was created, the Wallkill Engine and Hose Company No. 2. The 1860 Button and Blake hand-drawn pumper had almost 100 feet of hose, which gave it great extension to several streets. (Photograph courtesy of Marc Newman.)

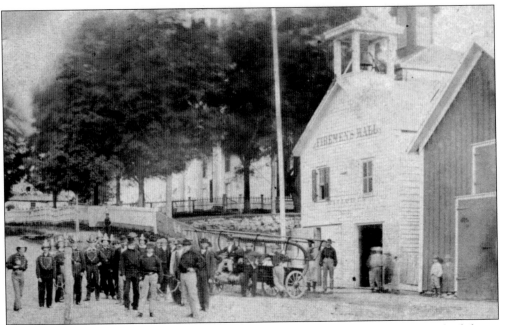

The firehouse was a two-story building with a small frame structure. There were two firefighting machines in which the pumpers were held inside. A bell tower was constructed with a solid brass bell that was pulled by a rope to sound the alarm. A newer brick firehouse was built in 1887. In 1893, the Independent Engine Company No. 1 was disbanded. Two years later, a board of water commissioners was created. (Photograph courtesy of the Village of Montgomery Museum.)

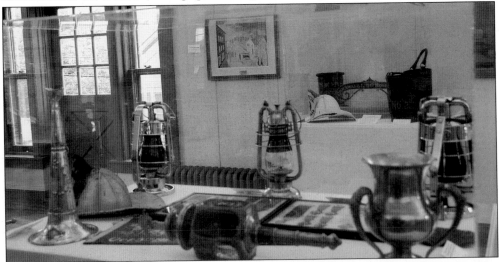

By the 1890s, fire hydrants made out of cast iron were installed throughout the village. Fire extinguishers dated back to 1723 in England. They contained liquids inside the canisters, which were exploded by gunpowder. Originally the canister was a copper container of about 3 gallons of potassium carbonate and compressed air. The soda acid extinguisher, developed in the United States in the 1880s, used sodium bicarbonate and sulfuric acid. Lanterns were used to illuminate streets and areas to guide firefighters to the scene of a local fire. These lanterns were carried by Colonial firefighters and were then made a permanent part of a fire carriages in the year prior to and after the Civil War. (Photograph courtesy of Marc Newman.)

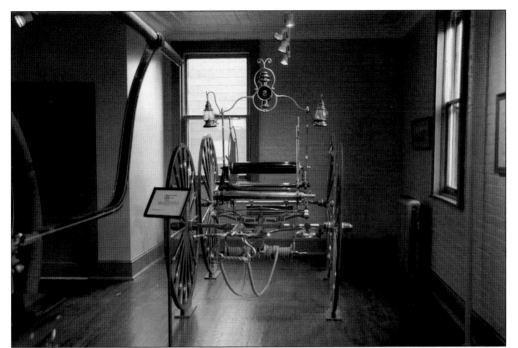

Two fire companies made up the Village of Montgomery Fire Department, the Hook and Ladder Company and the Wallkill Engine and Hose Company. During the 1890s, the Fleet Hook and Ladder Company No. 1 purchased a Gleason and Bailey truck and hose pumper. Both fire companies enlisted volunteers and formed a marching band. (Photograph courtesy of Marc Newman.)

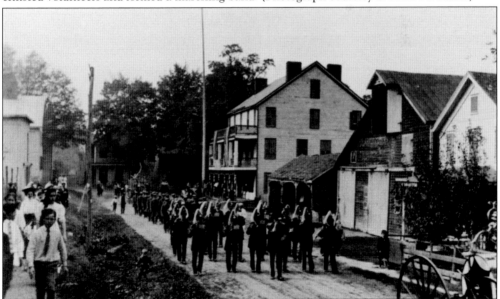

The 1890s was a period of popularity for march music. The composer and "March King" John Philip Sousa had created memorable marches such as *Semper Fidelis*, the *Washington Post March*, and the *Stars and Stripes Forever*. Sousa alternated with performances of music from light operas and had singers and dancers entertain the audiences. This photograph is of Ward Street showing Shafer's Wallkill Hotel. (Photograph courtesy of Robert L. Williams.)

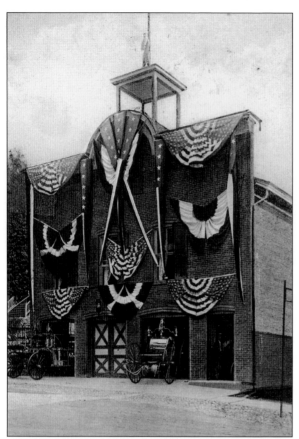

By 1901, with the purchase of a "Parade Carriage," the fire department had parades with their new dress hose carriage along with the marching bands of the companies. Gold and silver gilding on parts of the machine were typical of the Gilded Age of the 1890s. It not only represented the success of the community to have such a machine but had a symbolic importance as well. (Photograph courtesy of Robert L. Williams.)

In 1902, a horse-drawn hose cart was purchased by the Wallkill Engine and Hose Company. Its purpose was to carry fire hoses to the fire. Most of these two-wheel carts were drawn by one or two horses. Aside from extra lengths of hose, the carts would carry a tool chest, brass fittings to connect to other hoses, and a fire ax. (Photograph courtesy of Marc Newman.)

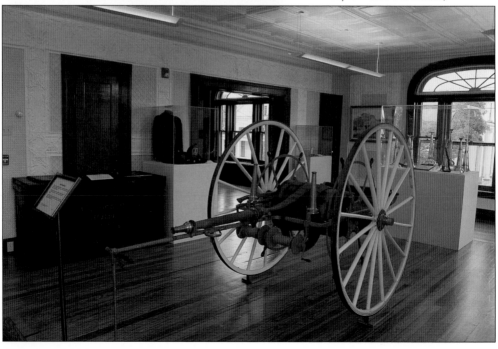

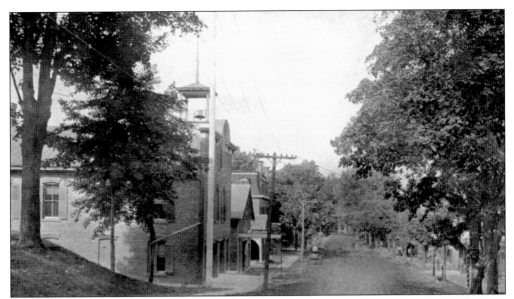

In 1913, the village sustained the worst fire in the history of Montgomery. The fire started on the south side of Clinton Street in the stables of the Iroquois Hotel (formerly the Palace). It engulfed the stables, fire house, and academy building and damaged the village bandstand and the Presbyterian church. The damage was so destructive that the old pumper from 1816 was seriously scorched and damaged. (Photograph courtesy of Robert L. Williams.)

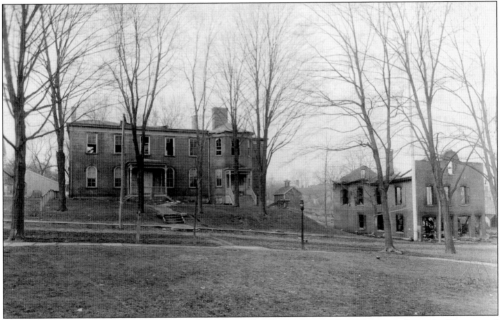

The fire was started in the stables by Hugh Carroll, who had been drinking very heavily. He started to light a cigarette as he slowly fell asleep. Soon after, his cigarette ignited a fire in the hay, and the fire spread very quickly. From the stable, the fire burned the western side of the academy building. Carroll was killed in the fire. Two men who were locked up in the basement of the fire house were quickly released. One later revealed that he had never been so near to Hell in all his life. (Photograph courtesy of the Montgomery Fire Department.)

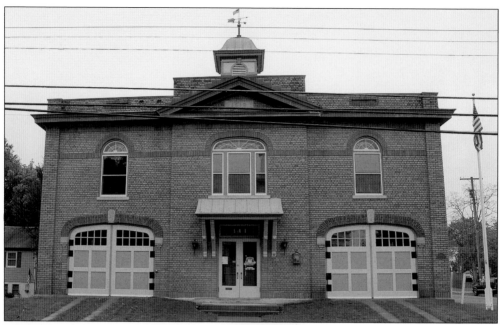

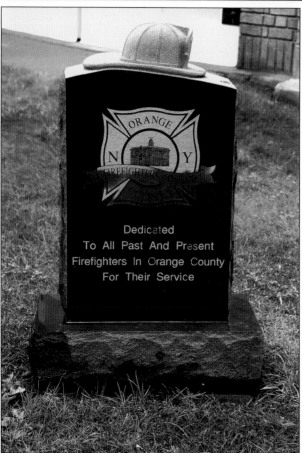

Dedicated
To All Past And Present
Firefighters In Orange County
For Their Service

The Wallkill Engine and Hose Company, along with the Fleet Hook and Ladder Company, had about 65 members and could not contain the fire of 1913. In 1913, a new brick firehouse was built with a basement containing two cells for lockup. The two-story building had barn doors for the wagons and machines. The two bays were large enough for fire equipment and accessories, including the hose-drying area. (Photograph courtesy of Marc Newman.)

In respect for all the men and women who have served as volunteers and have supported the various fire departments throughout Orange County, including the Village of Montgomery, this monument was created in recognition of their service. The monument was installed in April 2008. (Photograph courtesy of Marc Newman.)

Four

HISTORIC BUILDINGS AND DISTRICTS

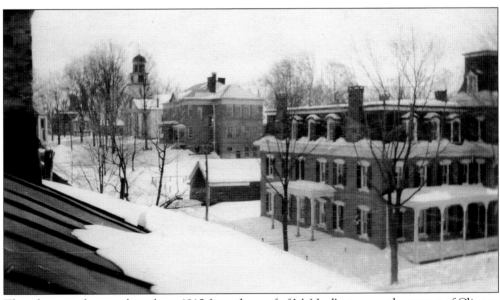

This photograph was taken about 1915 from the roof of McNeal's store on the corner of Clinton and Union Streets and shows the former Palace Hotel as well as the academy and Presbyterian church. Due to the abundance of architectural integrity that survives in the village, and to help prevent the diminishing of its character, the Union Street–Academy Hill Historic District and Bridge Street Historic District were established in 1979. (Photograph courtesy of Robert L. Williams.)

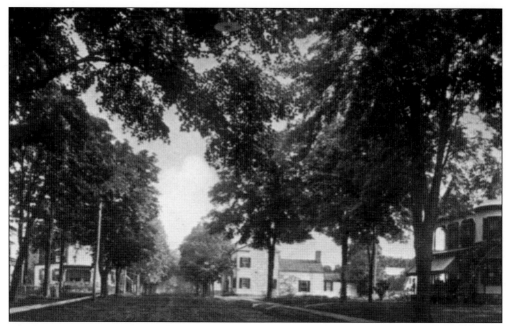

The Union Street–Academy Hill Historic District takes up much of Union Street from the area of Sears Street to Charles Street, where it extends to Clinton and Ward Streets. The Bridge Street Historic District includes that portion of Bridge Street between Elizabeth and Charles Streets, extending east onto Clinton Street and a small portion of Elizabeth Street. The above view of Union Street was taken from Boyd Street looking northeast in the early 1900s, while the lower view was taken from River Road about the same period. The building partially covered by trees to the left of the bridge was D. A. Shafer's Wallkill Hotel, which was sadly taken down in 1956. The white house to the right of the bridge was the Brown residence, which originally had a gambrel roof that was modified in the 1890s to the gabled roof. (Photographs courtesy of Robert L. Williams.)

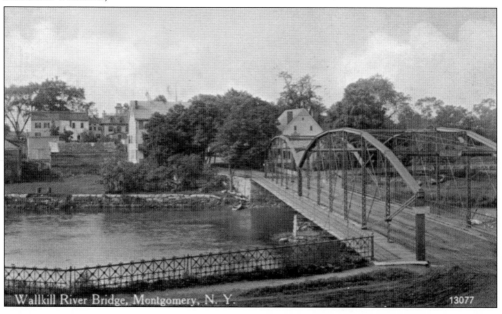

Wallkill River Bridge, Montgomery, N. Y. 13077

Both historic districts contain a unique blend of Federal, Greek Revival, and Victorian-era styles, which are pronounced in many of the surviving homes with original detailing. Some of these homes, like the *c.* 1812 Sears House at 60 Union Street, were expanded later in their history but still retain original detailing on the interior and exterior. These postcard views of Union Street were taken in the early 1900s. The above view was taken from the corner of Sears Street and looks northeast in the direction of the Catholic church, while the view below was taken nearly in front of the Sears House, showing the house and adjacent carriage shop. All the homes viewed in both pictures survive today. (Photographs courtesy of Robert L. Williams.)

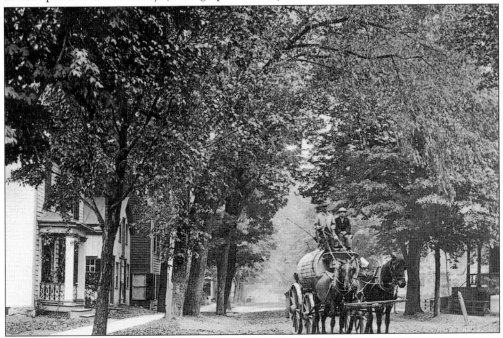

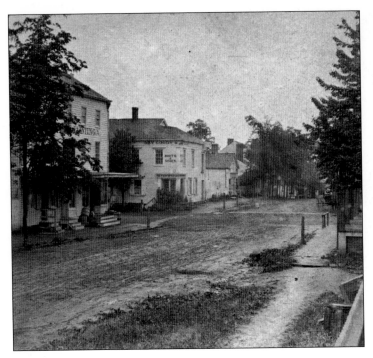

Residences and businesses radiated outward from the village center at the intersection of Clinton and Union Streets. This photograph was taken from the corner of Union and Charles Streets and looks northward on Union Street. It is from one of J. Barnes's stereopticon cards dating from about 1870. Barnes's views of Montgomery are noted to be the earliest on record, giving a unique glimpse of how the village originally appeared. (Photograph courtesy of the Village of Montgomery Museum.)

The Gillespie House stands on the southeast corner of Charles and Union Streets. Believed to have been built about 1810, the house was remodeled into a Victorian-era design with two-over-two windows and a simple Victorian doorway with a porch and cornice gutters. In recent years, the Victorian porch was removed and a stoop set in place as seen in this c. 1870 Barnes photograph. (Photograph courtesy of the Village of Montgomery Museum.)

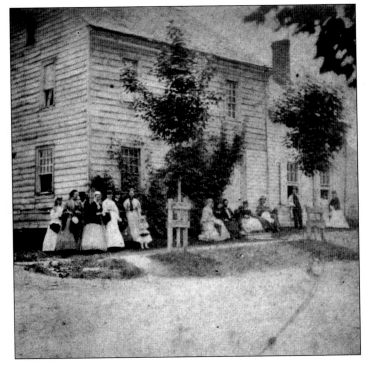

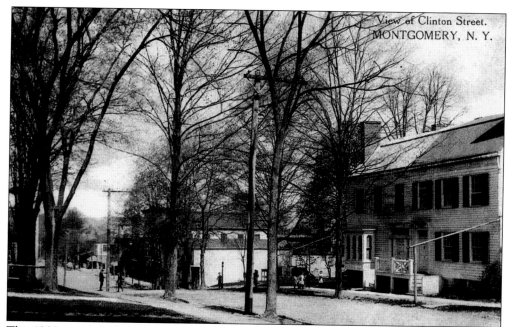

This 1900s view of Clinton Street was taken from the front lawn of the Presbyterian church. The gambrel duplex on the right side of the photograph is the Mead-Tooker House and dates from the early 1800s. The doorway to the right, with simple overhead transom and carved sunburst, is original to the house; initially the one to the left would have been identical. (Photograph courtesy of Robert L. Williams.)

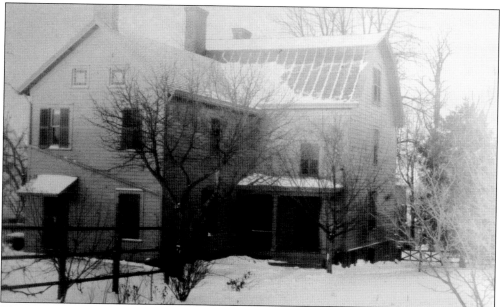

The Eager House on the corner of Union and Mason Streets dates from about 1820. Built in the Federal style, the house was updated in the 1890s. The interior contains a nice blend of Federal and Victorian detailing. Reputed to have been built by M. Mead, builder of the Presbyterian church, the home later became the residence of George Eager, who, with William and John Crabtree, photographed Victorian Montgomery. (Photograph courtesy of Robert L. Williams.)

One of the most outstanding Federal-era features is the carved cornice board over the front doorway of the Dr. Milspaugh House at 54 Union Street. This duplex with a kitchen wing dates from the early 1800s. Although sided with aluminum years ago, it is suspected that a decorative cornice is covered over below the gutter system. If this is the case, it would be one of two noted to have existed in the village. (Photograph courtesy of Robert L. Williams.)

Little is known about this home, which stands at 13 Hanover Street. Judging by the proportions of the house, it would appear to date from the early 1800s. The smaller wing to the left of the main block contained the keeping room or kitchen, which undoubtedly featured a hearth with an adjacent beehive bake oven. This photograph dates from about 1905. (Photograph courtesy of Robert L. Williams.)

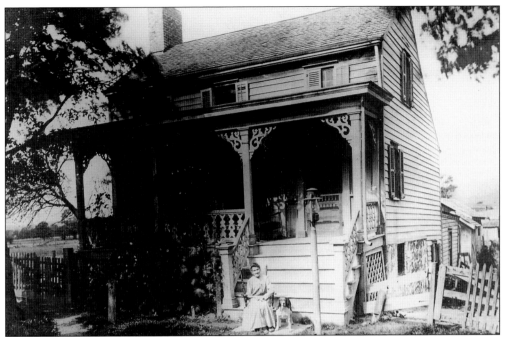

This small home dating from the first half of the 19th century can be found at 10 Hanover Street, on the west side of the street and outside the bounds of the historic districts. Judging by the style of the front doorway, with its flat pilasters and sidelights, the building is Greek Revival in style, most likely placing it in the 1840s. The 1903 map lists it as the home of Emmet Gridley. (Photograph courtesy of Robert L. Williams.)

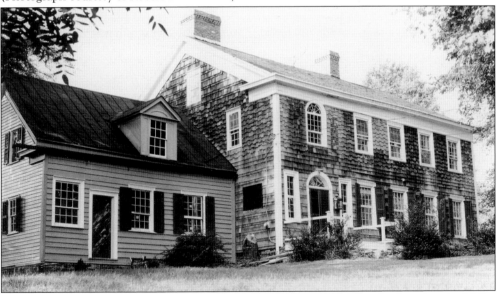

One instance where the smaller wing is older than the main block can be found at the Miller Homestead, otherwise known as Montgomery House on Route 211, opposite Route 416. This home is one of the individual National Register listings and has been restored by current owner Robert Wiggins. The smaller wing was built in 1771 by Hans Smith, while the larger Federal-era block was built for local entrepreneur Johannes Miller. (Photograph courtesy of Robert Wiggins.)

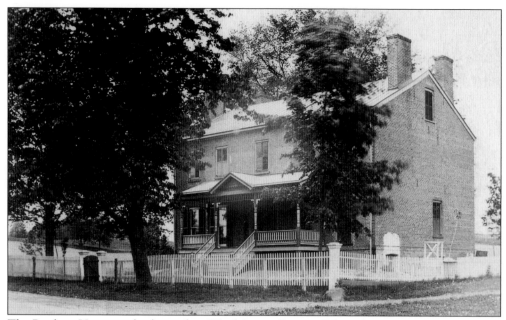

The Patchett Homestead is located on Ward Street (Route 17K) at the corner of Factory Street and is one of the individual National Register listings in the village. Dating from the early 1800s and built in the Federal style, one of its initial uses was said to be that of a tavern. When Arthur Patchett purchased the house in the early 1890s, he hired Chauncey Brooks to make a number of changes in the Queen Anne Victorian style, including the expansion of the porch and the installation of three large dormers. These were replaced about 1920 with the current Federal Revival–style dormers. The porch was also adapted to the Colonial Revival style and remains today. Recently restored, the house retains a nice blend of its original Federal woodwork along with the remodeling from the Victorian and Colonial Revival eras. (Photographs courtesy of Robert L. Williams, Crabtree collection.)

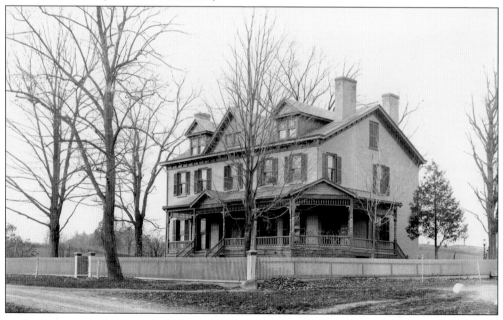

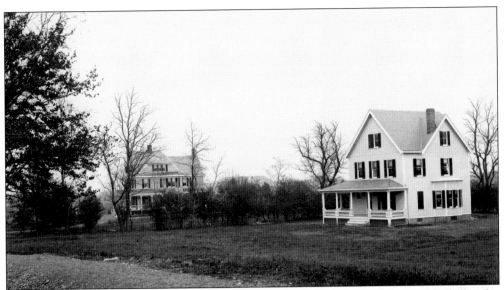

The John Crabtree House is located on the east side of Factory Street at the top of the hill and is one of the most recent National Register listings in the village. Built in 1899–1900 by Chauncey Brooks for the price of $1,925, the house was designed by W. J. Keith of Minneapolis and is Queen Anne Victorian in style. A two-story rear porch with pantry was added about the time of World War I, and during the 1920s, the living room and dining room were expanded to the east and a small library added, bringing the house to its current appearance. Nearly all interior and exterior architectural integrity of the house and property remains intact, making it one of the most unique properties in the village. Recently restored, the house has been featured in *Old House Journal* and on HGTV. (Photographs courtesy of Robert L. Williams, Crabtree collection.)

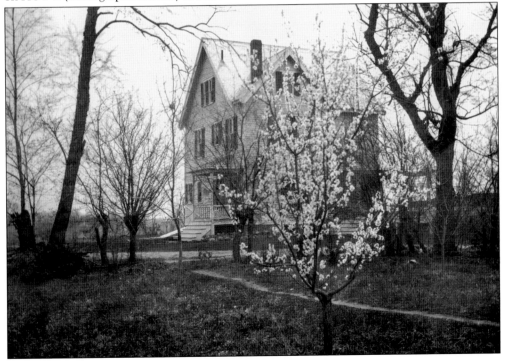

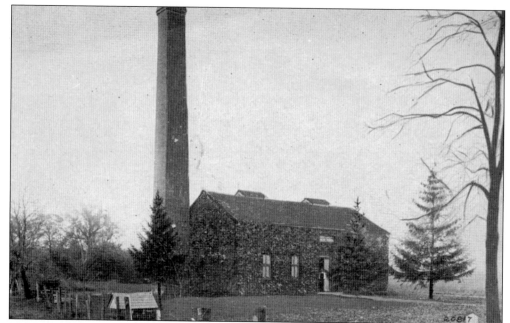

Montgomery's old pumping station was recently added to the State and National Registers of Historic Places. Dating from 1895, the building was constructed during a time of growth and prosperity for the village, and as a result, a public water system became a necessity. A standpipe was also built on the top of the hill above Prospect Terrace. The pumping station is no longer in use but remains in village ownership. (Photograph courtesy of Barbara Conroy.)

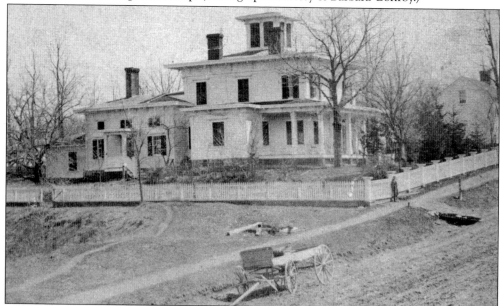

Built in 1846 in the Italianate Victorian style, the Eager House can be found within the Academy Hill Historic District on the north side of Ward Street adjacent to the firehouse property. At the end of the 19th century, this was the home of William Eager. The house today retains much of its original integrity, including wide plaster cornices in interior rooms and wide moldings. This Barnes photograph dates from about 1870. (Photograph courtesy of the Village of Montgomery Museum.)

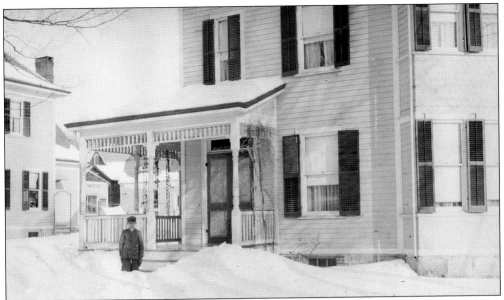

The Stratton-Hadaway House at 67 Union Street was built by Chauncey Brooks in 1895–1896, and its style is also indicative of the Queen Anne Victorian era, complete with fish-scale shingling and bay windows. Built for Joseph Stratton and family, the house later became the residence of his niece and nephew-in-law, Anna Stratton and Frank T. Hadaway. Frank was a prominent resident serving in a number of important positions in the village, including that of postmaster. He was also one of the original trustees of the Montgomery Free Public Library when it was organized early in the 20th century. The house later passed to Frank's son, Thomas Renwick Hadaway. Both photographs date from about 1912. The interior photograph below shows the parlor with mantelpiece. The bronzed fireplace cover features the imprint of a young boy listening to his father's pocket watch. (Photographs courtesy of Robert L. Williams.)

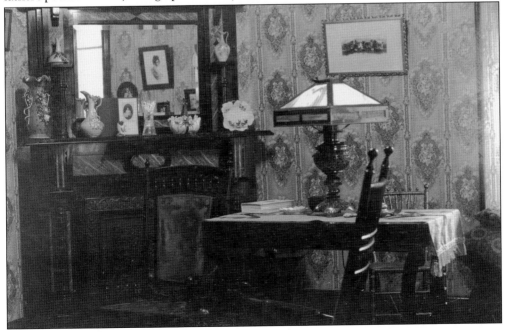

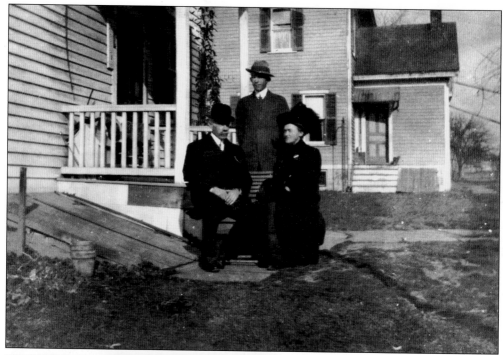

This rear view of the Stratton-Hadaway House was taken about 1912, showing Frank and Anna Hadaway with their eldest son, William. The porch behind where they stand was later removed and replaced with a newer kitchen wing after World War II by Tom Hadaway and his wife. The house in the background is 63 Union Street, also known as the former residence of Dr. Robert Kerns, one of Montgomery's prominent physicians. (Photograph courtesy of Robert L. Williams.)

As with the previous photograph, this picture was taken behind the Stratton-Hadaway House and shows young Tom Hadaway. He would rise to the position of distinguished attorney and Orange County judge. The house has been sensitively restored by current owner and historian Robert L. Williams in conjunction with, and with guidance from, Montgomery's Architectural and Historic Review Board, which assists those in the village with historic homes. (Photograph courtesy of Robert L. Williams.)

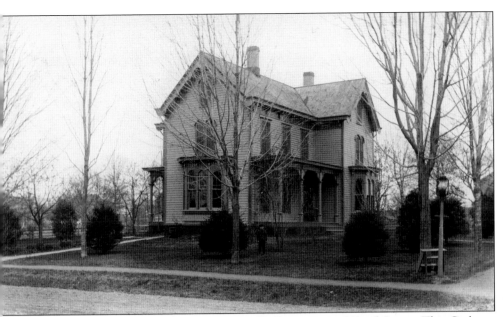

This home is located on the south corner of Wallkill Avenue and Boyd Street. This Crabtree photograph was taken in the 1890s, and according to old maps, this was the home of A. Woolsey, of whom little seems to be known. It has been meticulously restored by its current owners, Alan and Barbara Fox, including the refabrication of the front arched doorway, which had been removed years ago. (Photograph courtesy of Robert L. Williams, Crabtree collection.)

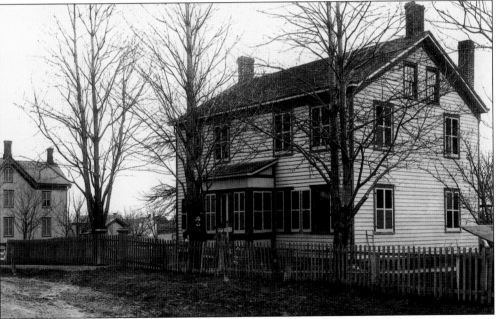

As with the Woolsey House, this home is not within either of the historic districts but is among the village's venerable old homes. Listed as the home of G. Comfort on the 1870 map, it is located at 97 Wallkill Avenue. As with many of the village homes, this is believed to have been built by local contractor Chauncey Brooks. By 1903, this is listed as the home of C. R. Stanley. (Photograph courtesy of Robert L. Williams, Crabtree collection.)

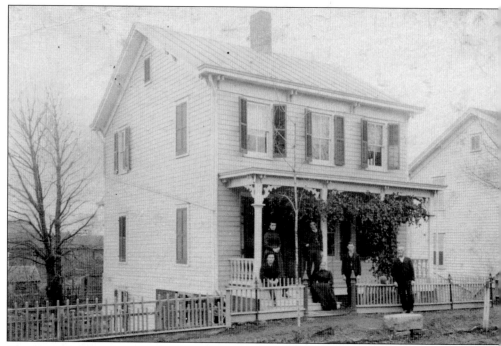

Chauncey Brooks was enticed to Montgomery as a result of the Wallkill Valley Railroad, which was constructed in the late 1860s. The earliest homes he constructed around 1870 were a series of four along Wallkill Avenue, among which this is the first in the series. This beautiful old photograph dates from about 1890 and shows the house as it originally appeared at 41 Wallkill Avenue. (Photograph courtesy of Tom and Jenny Jones.)

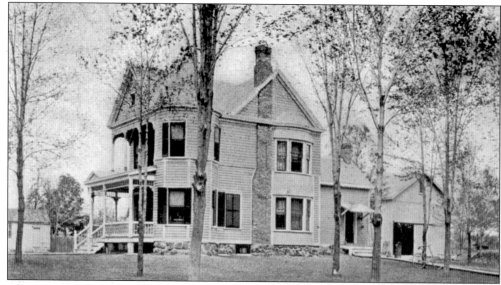

Chauncey Brooks was surely a busy person in the 1890s, when Montgomery was experiencing a spurt in growth. He built this Queen Anne Victorian home on the corner of Boyd and Union Streets. The rounded tower section and decorative shingling are indicative of the Queen Anne style. This turn-of-the-century view labels it the home of Dr. Elliott. (Photograph courtesy of Robert L. Williams.)

The former home of Fayette Sparks is located at 24 Bridge Street. The outward appearance of the building helps date it to the mid-Victorian era, but a study of the exposed attic framing reveals a much older structure with hand-hewn rafters. It was not uncommon years ago to recycle old structures and put them to other uses, as is suspected to be the case with this building. A recent owner removed the false siding, exposing the original. (Photograph courtesy of Robert L. Williams.)

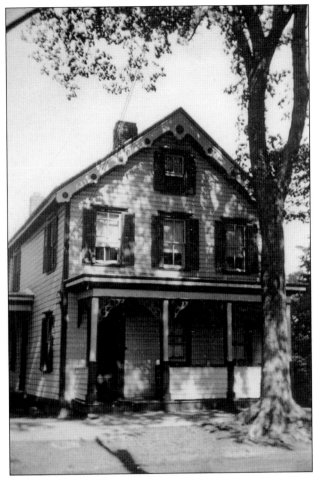

This wonderful old photograph was taken by the Crabtrees and dates from 1891. More familiarly remembered as the Suydam residence, the old post lamp bears the name of Dr. Wallace. The home was among the first built by Chauncey Brooks and was owned by James Vanderoef, who was partial owner of the profitable coal and lumberyard nearby. Its approximate date of construction is about 1870. (Photograph courtesy of Robert L. Williams, Crabtree collection.)

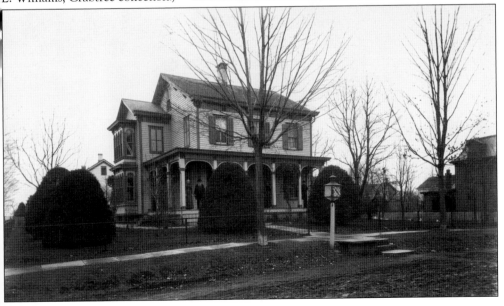

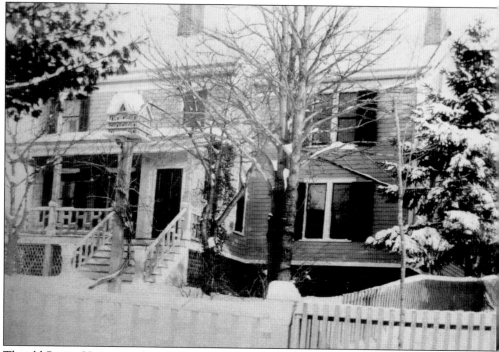

The old Senior House stands at 31 Prospect Terrace and dates from the 1890s. Built by Chauncey Brooks, the house was occupied by the Senior family in its early years. The Seniors were among the most prominent residents in the village, having owned and operated Senior's Store on Clinton Street, which was the department store of its day. Notice the three-story birdhouse in front of the house in the photograph above. The Senior house is not within either of the historic districts, but, as with so many others, it remains an important link to Montgomery's rich and colorful heritage. Several years ago, the house was included in the movie *The Night Listener*, starring Robin Williams. (Photographs courtesy of Robert L. Williams.)

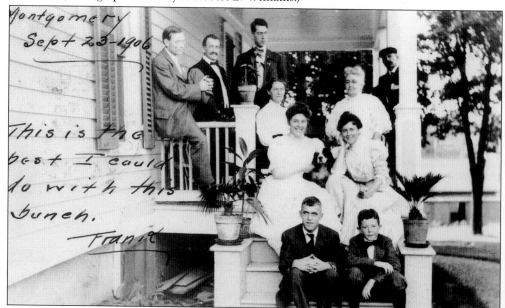

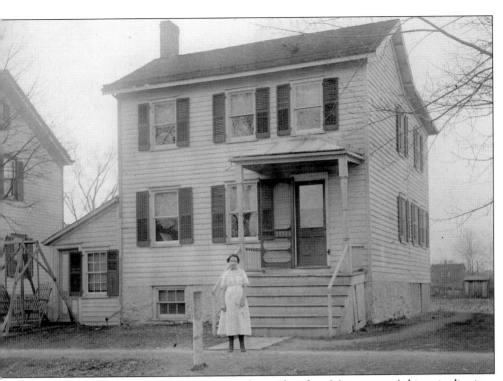

As with the Senior home, this dwelling is not located within Montgomery's historic districts. Its exact date of construction remains clouded by the veil of time, but it undoubtedly dates to the second half of the 19th century. Beautifully restored, the house can be found at 157 Mason Street. This photograph dates from about 1905, showing the home with its Victorian-era porch, which has since been removed. (Photograph courtesy of Robert L. Williams.)

The Sheard House (155 Clinton), dating from the fourth quarter of the 19th century, was built by Chauncey Brooks. Seated from left to right are Hannah Sheard, unidentified, Mary Crabtree Sheard, Alice Patchett, Harriet Crabtree, and unidentified. This photograph was taken shortly after the Stratton family vacated the house and took up residence in their new home at 67 Union Street. (Photograph courtesy of Robert L. Williams, Crabtree collection.)

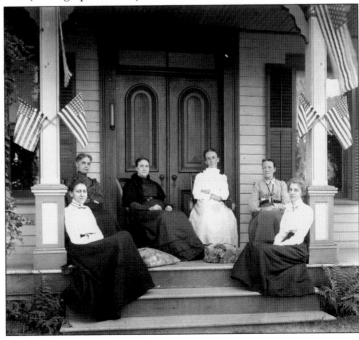

Located outside the historic districts at 265 Goodwill Road, in the vicinity of Presidential Heights, little has been identified by the authors about this home to date. Its architectural style would date it from the 1870s, and the house is today utilized by AHRC (Association for the Help of Retarded Citizens) as a group home. This photograph dates from 1906. (Photograph courtesy of Robert L. Williams.)

The William H. Senior House stands at 113 Union Street and was also built in the Queen Anne Victorian style around the end of the 19th century. The scale of the house, combined with its circular drive, attests to its opulence and the prosperity of the family who lived there. This photograph shows LeGrand Sparks with a friend and was taken June 16, 1907. (Photograph courtesy of Robert L. Williams.)

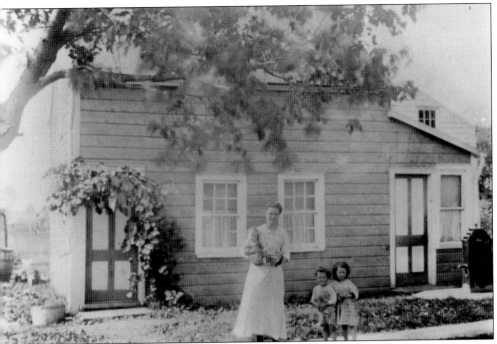

This small home most likely dates from the mid-19th century and stood on the south side of Charles Street, a short distance west of the corner of Bridge Street. It was purchased by Samuel and Ella Rosenberg about 1910, and here they raised 14 children. Ella is pictured here in this 1913 photograph with her two children, Sid and Kay. (Photograph courtesy of JoAnn Scheels.)

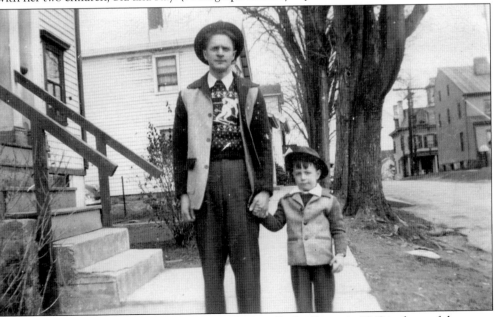

Herbert F. Rosenberg Sr. and Jr. are seen standing on Bridge Street in 1948 in front of the newer family home, built about 1840, on the corner of Bridge and Charles Streets. The house in the immediate background is the Thompson-McKinney House, believed to date from about 1880. (Photograph courtesy of Herbert F. Rosenberg Jr.)

Little is known about this house located at 114 Wallkill Avenue, which today has a wraparound porch. The building dates from about the end of the 19th century, and both photographs were found at the Hadaway estate auction, which was conducted in the autumn of 1989. Longtime and beloved resident Anna Hanlon, who has long since passed away, recalled that her husband, Earl Hanlon, had met silent-movie star Mary Pickford in this house, but unfortunately it is unknown why Mary Pickford was visiting Montgomery. Nonetheless, as with any historic home, many fascinating stories wait to be discovered. Montgomery's greatest asset is its historic buildings. It is this very source that lends to the quaintness of the village and attracts people far and wide. As such, it is imperative that the historic detailing of these buildings remain intact for posterity. (Photographs courtesy of Robert L. Williams.)

Five

CRABTREE AND PATCHETT

William Crabtree immigrated to the United States during the American Civil War in search of opportunity. Having learned the textile trade in John Foster's Black Dyke Mills in Queensbury, England, he set out on his own and settled in Philadelphia, where he applied his skills. He returned to England several years later to marry his childhood sweetheart, Harriet Patchett and returned to Philadelphia, where they were joined by Harriet's brother Arthur. This photograph of William dates from 1902. (Photograph courtesy of Robert L. Williams, Crabtree collection.)

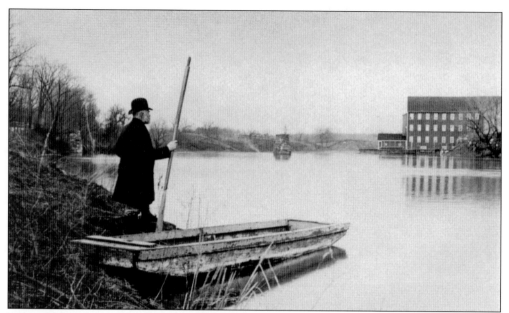

Through their own industriousness and frugality, along with financial support from the family in England, William Crabtree and Arthur Patchett decided to form their partnership and strike out on their own. They first considered the purchase of a factory in Pennsylvania, but while making plans to return to England to purchase machinery, Arthur heard that Edmund Ackroyd's mill in Montgomery was available, so they canceled their trip and came to Montgomery to have a look at the mill. They decided to purchase it. The above photograph of William looking across the river at the mill was taken March 15, 1890, and the below picture looking down Factory Street was taken around the same time. The building off to the right was the old tenement where both families first set up their residency. The oldest portion of this structure dated from 1826. (Photographs courtesy of Robert L. Williams, Crabtree collection.)

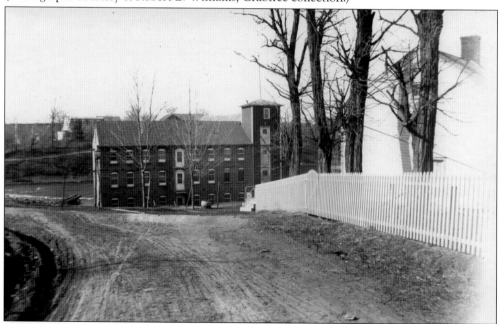

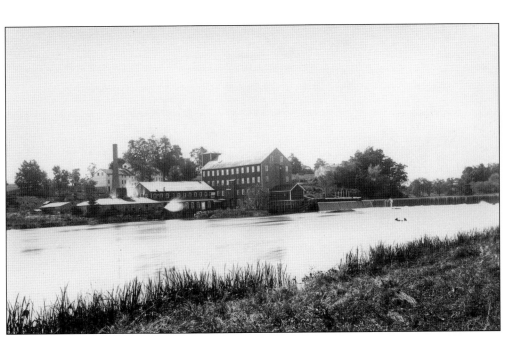

The large-frame block of the mill, shown above, was constructed in the early 1800s by a group of entrepreneurs. In Eager's 1846 history of Orange County, he notes in the biography of Johannes Miller that he was active in various community projects, "which involved the building of a cotton factory, which to the best of recollections, never spun a pound of yarn, nor wove a yard of cloth because the company failed before starting any manufacturing operations." When they purchased the mill, they added to the spinning machinery since their operation would exclusively deal with the manufacture of worsted yarns. By 1894, the operation was employing 100 workers, making them the largest employer in the village. The business card below dates from about 1890. (Photographs courtesy of Robert L. Williams, Crabtree collection.)

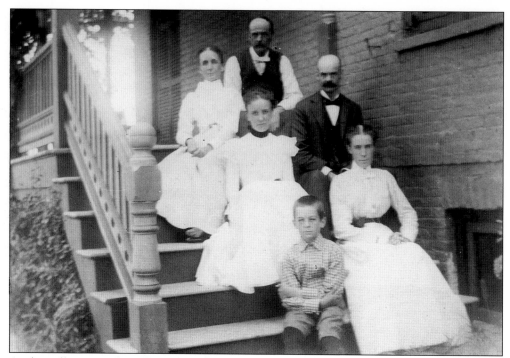

As the mill prospered, Arthur Patchett purchased the large brick house on the corner of Factory Street and Route 17K and moved there in 1891 with his wife, Alice Hayes, and their children. The house was sold out of the family in 1977 after the death of Em Patchett (right). This photograph of Arthur, seated at the top of the stairs, and his family was taken about 1900. (Photograph courtesy of Robert L. Williams, Patchett collection.)

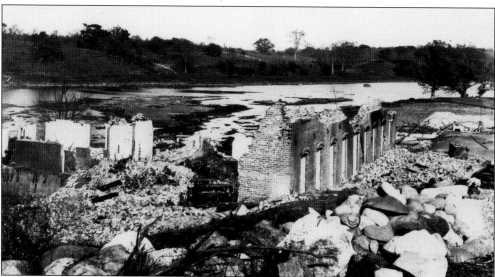

William Crabtree was set to build his new house on Factory Street until tragedy struck, which caused him to delay his plan. On Election Day, 1891, a fire reportedly started in the boiler room and quickly spread, engulfing the entire building in flames. This view, taken on November 7, 1891, shows the extent of the loss. Notice the safe on the ground at the far right of the photograph. (Photograph courtesy of Robert L. Williams, Crabtree collection.)

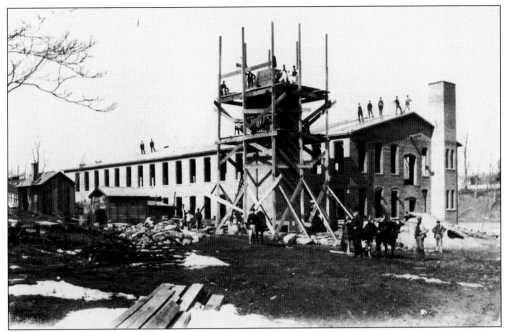

With the insurance money, which covered a portion of the loss, Crabtree and Patchett set out to build a new mill to house their operation. This March 1892 photograph shows that mill under construction, and all the workers took a moment to pose for this photograph. It was noted that some of the bricks from the old mill were cleaned off and used in the new building. (Photograph courtesy of Robert L. Williams, Crabtree collection.)

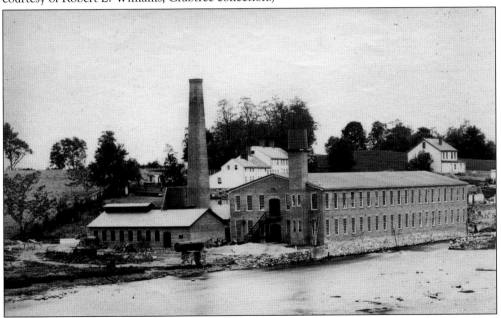

The new mill was completed in 1892 and back in operation. The narrow brick building behind the main complex was the dye house. Wool was dyed there in large vats and, weather permitting, was placed on large racks outside to dry. At the west (right) end of the main block of the mill was the small office. (Photograph courtesy of Robert L. Williams, Crabtree collection.)

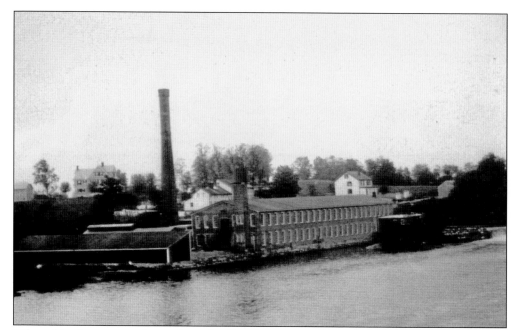

When this picture was taken, a large shed had been erected to hang the wool after it was dyed. The smoke stack had also been increased in height to the familiar size of today. At the time this picture was taken, about 1896 or 1897, the tenement to the right of the smokestack was used to house mill workers, as was the two-family house above the mill. (Photograph courtesy of Robert L. Williams, Crabtree collection.)

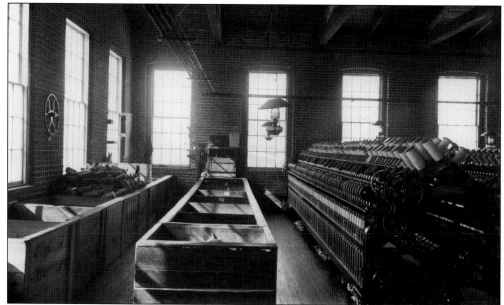

This is the spinning room of the new mill as it appeared at 2:00 p.m. on March 3, 1894. The wooden bins contained the spools that would go onto the spinning machines. The machine shown here was manufactured by Prince Smith and Son and was powered by a belt drive. According to a more recent occupant of the mill, the spirit of William Crabtree is noted to have occasionally been seen observing workers and equipment. (Photograph courtesy of Robert L. Williams, Crabtree collection.)

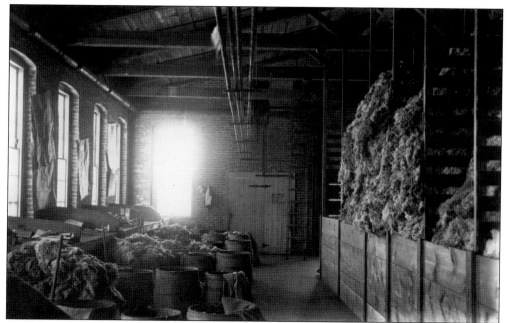

This picture of the wool room was taken the same day as the previous photograph. Raw wool was purchased by the firm far and wide. Some was domestic, but other bales came from Iceland, Australia, and South America. From the wool room, the raw wool would be scoured, then blended, and eventually made into worsted yarn, which was sold to weaving and knitting mills. (Photograph courtesy of Robert L. Williams, Crabtree collection.)

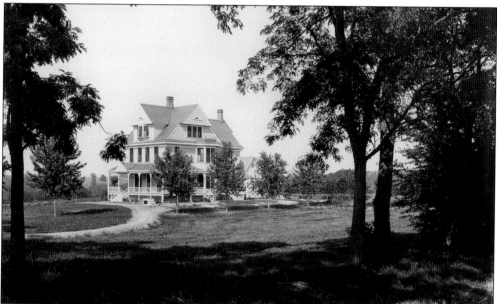

With the new mill completed, William Crabtree was able to focus his attention on building his new home on Factory Street. Designed by architect Mapes in the Queen Anne Victorian style, the house was built by Chauncey Brooks and completed in 1896. It was among the finest modern homes in the village in its day. Three of William's sons would also build their homes on Factory Street. (Photograph courtesy of Robert L. Williams, Crabtree collection.)

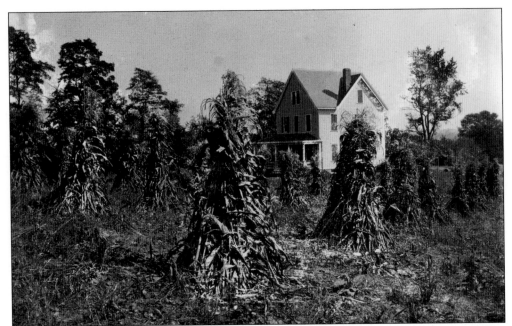

William's son John built the second house on the upper portion of Factory Street in 1899–1900. This view, showing the house among the cornstalks, was taken shortly after it was built. William Jr. would build his house between John and his father's in 1903, and Charlie would build his home on the opposite side of Factory Street in the 1920s. (Photograph courtesy of Robert L. Williams, Crabtree collection.)

This 1890s view was taken from the attic of William Sr.'s new home looking toward the direction of the mill and Factory Street. William's son Harry lived in the two-family house near the center of the photograph. The old tenement can be seen to the right of this photograph. (Photograph courtesy of Robert L. Williams, Crabtree collection.)

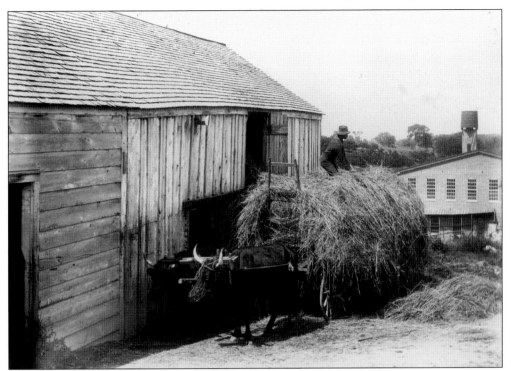

Besides the milling operation, the Crabtrees and Patchetts also ran a farm surrounding the mill. Hay is being loaded from the oxen-pulled wagon into the barn, probably around the mid-1890s. Farming was a labor-intensive and back-breaking job at this time, lacking many of the modern-day conveniences that would come in the 20th century. This barn was later replaced by the current barn on the property west of the mill. (Photograph courtesy of Robert L. Williams, Crabtree collection.)

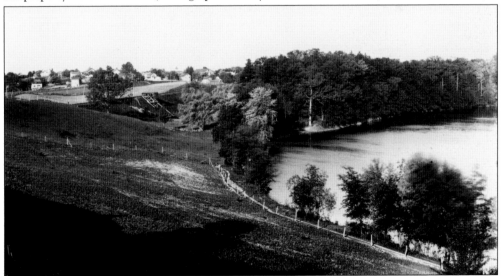

Mill workers would come to and from the mill by way of the path along the Wallkill River. This extended from above the barn and west to the railroad tracks that led into the village. The path still survives in its entirety today and makes for both a peaceful and historical nature walk enjoyed by area residents. (Photograph courtesy of Robert L. Williams, Crabtree collection.)

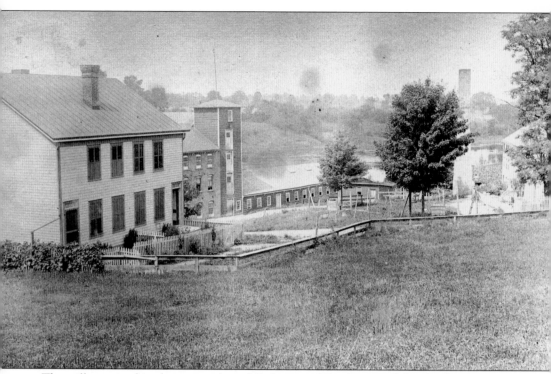

The mill remained in the partnership of Crabtree and Patchett until dissolved and reorganized after the death of Arthur Patchett in 1901. William purchased his partner's interest, and the firm of Willam Crabtree and Sons was created, which sadly resulted in a rift between the two families. Shortly after the reorganization, William suddenly died while on vacation in England with his wife. Their sons carried on until the mill fell on hard times during the Great Depression and was sold out of the family. This 1890s view looks from the barnyard in the direction of the original mill. (Photograph courtesy of Robert L. Williams, Crabtree collection.)

Six

BUSINESSES

For years, agriculture was the base of Montgomery's economy. As the village slowly developed, stores and businesses were established to support the agricultural base and farming families. In the Federal, Greek Revival, and Victorian eras, the village received a boom in growth, which resulted in the establishment of stores and homes. This view of Union Street looks southward from near the corner of Charles Street and shows the village blacksmith shop among other buildings. (Photograph courtesy of the Village of Montgomery Museum.)

Commercial space was established throughout the community at an early date as the village slowly developed as a center of activity. Among other businesses, a jeweler located on the east corner of Clinton and Union Streets is seen about 1870. This Greek Revival structure is currently incorporated into the current corner building. (Photograph courtesy of the Village of Montgomery Museum.)

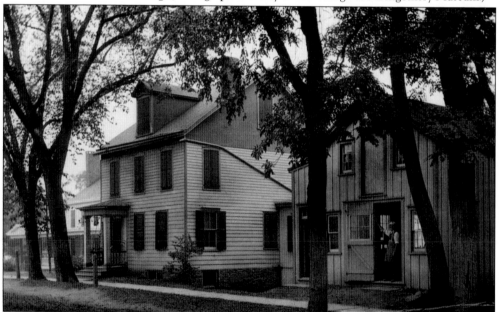

The wheelwright was a vital part of the community who built and repaired carriage and wagon wheels. This shop was located at 58 Union Street, although the building was remodeled to its current appearance when made into a residence in the early decades of the 20th century. Believed to date from the 1820s, the adjacent house was part of the property. (Photograph courtesy of the Village of Montgomery Museum.)

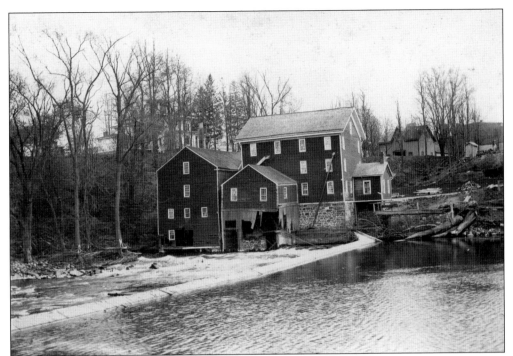

Stratton's mill stood on the Wallkill River, nearly opposite the beginning of Union Street. It undoubtedly dated from the first half of the 19th century. The smaller wing, adjacent to the main building, may be the older section of the complex, which served as the flour mill. The operation fell on hard times early in the 20th century, as these types of operations slowly began to disappear. (Photograph courtesy of Robert L. Williams, Crabtree collection.)

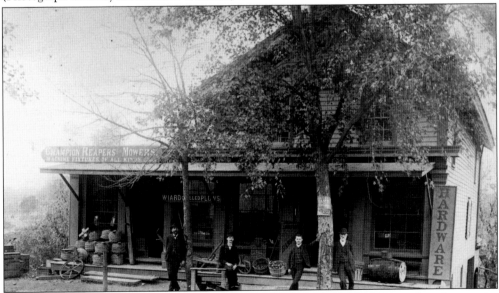

The mill property included this old store building, which stood on Ward Street directly opposite Union Street. Built in the Greek Revival style, indicated in the flat pilasters supporting the cornice of the storefront, the building served as J. Comfort's Hardware at the time this photograph was taken in the 1890s. (Photograph courtesy of Robert L. Williams.)

Down the street from Comfort's Hardware stood this small building dating from the early years of the 19th century. Its original purpose remains a mystery, but it is obvious that it served as a shop of sorts. An 1880s insurance map lists use of half the building as a "Bl. Sm.," presumably a blacksmith. Buried in the grounds nearby were many scraps of tin; perhaps it once served as a tinsmith's shop. (Photograph courtesy of Robert L. Williams, Crabtree collection.)

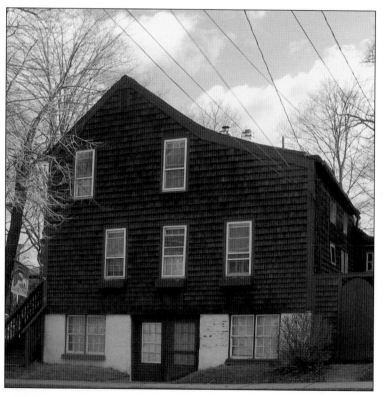

George Overhiser's cabinet shop was located on Union Street. Here he built furniture as well as caskets. A beautiful slant-front cherry desk made by him remains a testament to his ability. Eventually the focus of the business was on funerals at a time when wakes were generally conducted from the deceased person's residence. Overhiser Funeral Home remains in the village in the original Overhiser home, but it is no longer owned by the family. (Photograph courtesy of Carol Daley.)

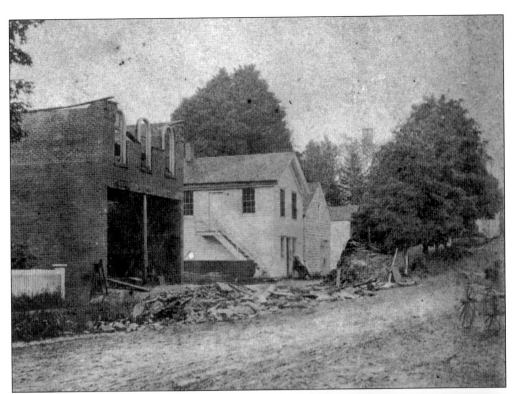

When the railroad came to town in the late 1860s, the village received another stimulus in growth. The new brick Senior store is shown being built above about 1870 and as it appeared after the turn of the century at right. This unique building retains a significant amount of its historical integrity today. On the east-side wall are the names of local children with dates etched into the bricks. The newer Senior department store, which older village residents recall, would be constructed on the lot east of the brick building (to the right). (Photographs courtesy of Robert L. Williams.)

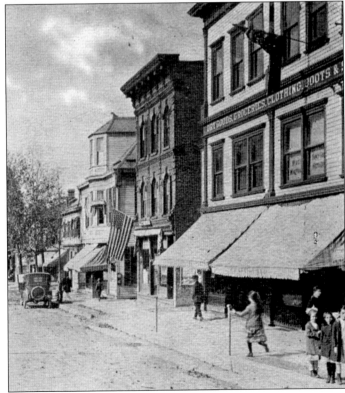

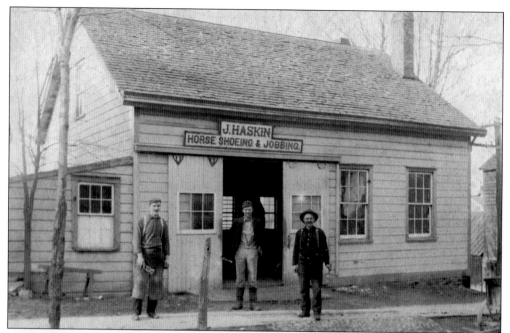

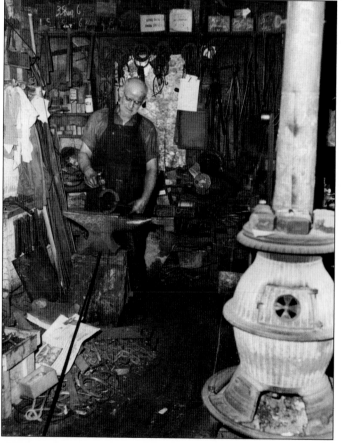

The blacksmith shop was a familiar part of everyday village life. Here people would take their horses to be shod and hinges and the like to be made and repaired. In its day, the village had several blacksmith shops, although Haskins, which stood on the corner of Union and Charles Streets, is the one most older village residents remember. The sound of the forge at work and the banging of the hammer on the anvil were familiar to those passing by. This site has served as a village blacksmith for many years, and this is thought to be the second such shop on this property. The building has been beautifully refurbished and now serves as Montgomery Sporting Goods. (Above, photograph courtesy of Barbara Conroy; left, photograph courtesy of Gertrude Greene.)

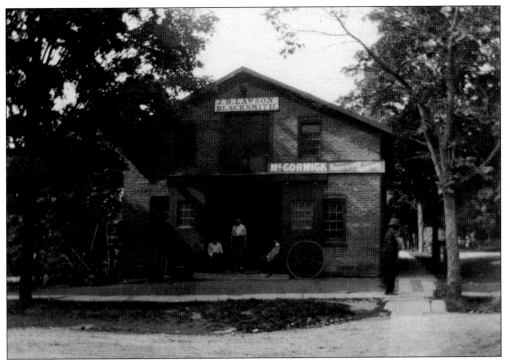

Lawson's blacksmith shop stood on the south corner of Wallkill Avenue and Charles Street and possibly dated from the Civil War era. Up until recently, the building still retained remnants of the old forges. It is now a two-family residence. This turn-of-the-century photograph shows the building as it originally appeared. (Photograph courtesy of Ed Devitt.)

In its day, Eager's Pharmacy was noted to be one of the oldest drugstores under continuous operation by one family in New York state, and its old pharmacy bottles can still be found in the area. The business was established by Dr. George Eager in 1816. The business closed in 1945, about five years after this picture was taken, and the building had since been made into residential units with the storefront removed. (Photograph courtesy of Robert L. Williams.)

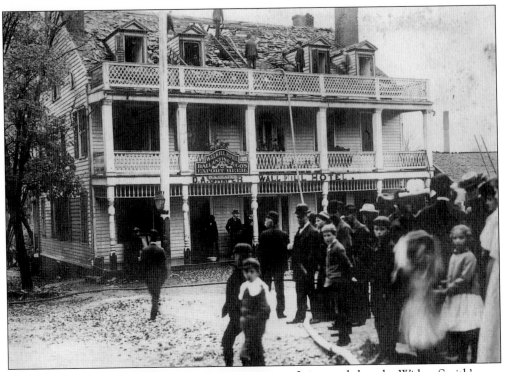

It is noted that the Widow Smith's Tavern once stood on the corner of Ward and Bridge Streets, where the vacant lot is today. It was moved when the two-and-a-half-story Federal-era Wallkill Hotel was built. Its replacement featured a two-story porch and dormers. This view of the 1903 fire was taken when the tavern was owned by Daniel A. Shafer. (Photograph courtesy of Robert L. Williams.)

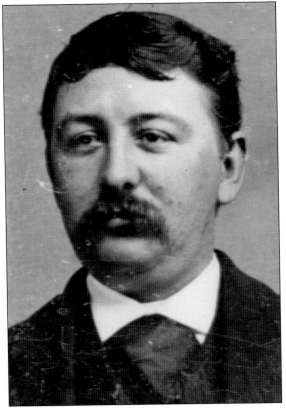

Daniel A. Shafer (1849–1931) acquired the Wallkill Hotel from his father's estate (D. A. Shafer I) in 1886 and operated it until 1916. Serving as village president for one year (1888), his greatest claim to fame was his side career of distiller. He produced his Kaiser brand of apple brandy at his distillery near Franklin Square and won a bronze medal at the Chicago World's Fair in 1893. (Photograph courtesy of Robert L. Williams.)

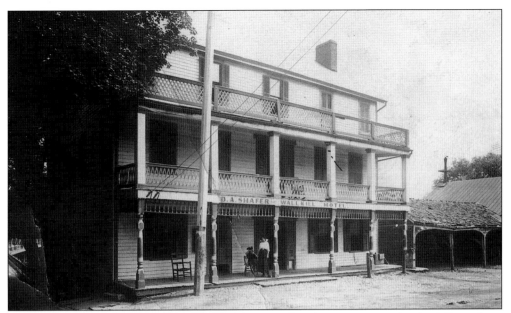

After the 1903 fire, Shafer contracted with Chauncey Brooks to construct the third floor where additional rooms were available to patrons. Dan's two children, Gladys (seated) and Madeline, are seen in this photograph on the front porch to the right of the barroom entrance. A ballroom was said to be on the top floor of the building, and there was an open dance pavilion in the backyard. (Photograph courtesy of Robert L. Williams.)

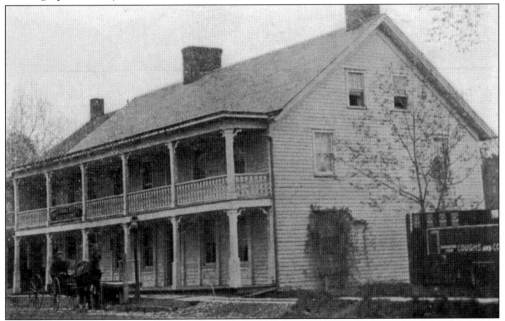

The former National Hotel stands on Clinton Street. The old building is said to have roots that extend back into the 18th century. As with the Wallkill Hotel, rooms were available for patrons on the second floor for a nominal fee. One of the celebrated guests here was Babe Ruth, and according to Bo Gill, Al Capone and his "enforcer" Frank Nitti used the place as a stop-over during Prohibition. (Photograph courtesy of Village of Montgomery Museum.)

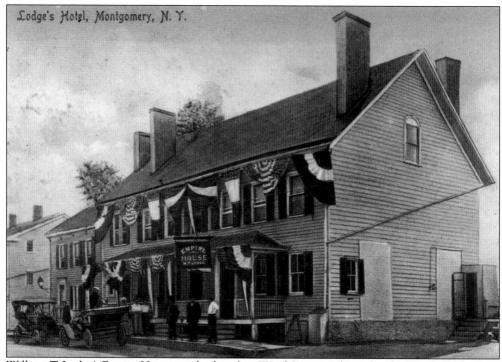
Lodge's Hotel, Montgomery, N. Y.

William T. Lodge's Empire House can be found on Ward Street and is today the Ward's Bridge Inn. Dating from about 1820, the building today boasts in excess of six fireplaces. As with D. A. Shafer, Lodge also had a distillery in addition to his popular hotel business. The small wing on the east side of the building was removed some years ago. (Photograph courtesy of Robert L. Williams.)

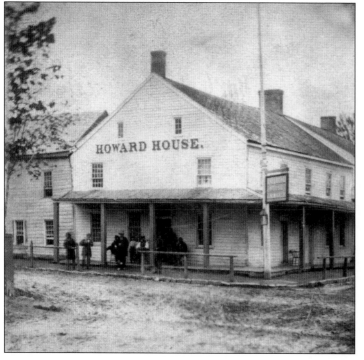

The Howard House was located on the south corner of Clinton and Union Streets and appears to have dated from the early years of the 19th century. This intriguing Barnes photograph dates from about 1870. One might question how such a small village could support such a large number of hotels, but with the convergence of the two turnpikes, now known as Routes 211 and 17K, Montgomery became a popular stopover. (Photograph courtesy of the Village of Montgomery Museum.)

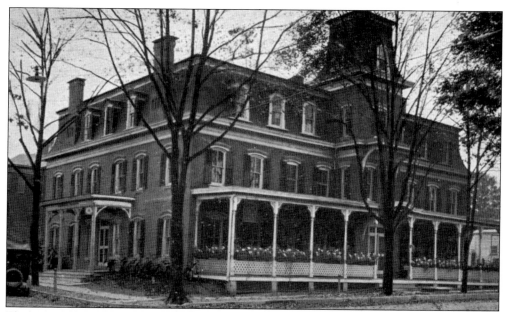

The beautiful brick Palace Hotel stood on the south corner of Clinton and Union Streets and replaced the Howard House. Believed to have been built in 1883, it was Italianate Victorian in style with arched windows and mansard roof. Of all the hotels in the village, this was the most opulent one of its day, complete with interior pocket doors, wide moldings, and decorative plaster cornices and ceiling medallions. Although coal-burning fireplaces were located throughout the building, early on it was switched over to steam heat. The photograph below shows one of the several parlors that were located on the first floor. The exterior photograph above dates from the early 1900s, while the interior is from 1921. (Photographs courtesy of the Village of Montgomery Museum.)

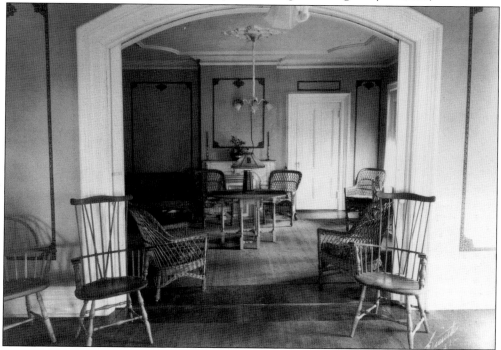

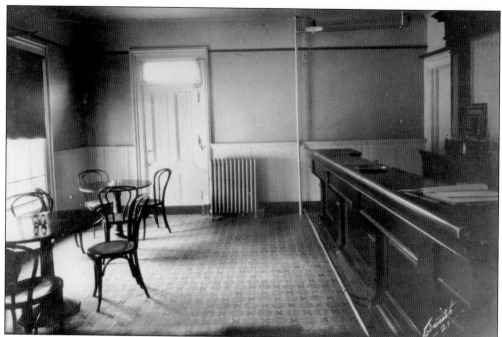

As with the other hotels in the village, the Palace had its own barroom. Note that the bottom of the barroom door is painted the same color as the surrounding baseboard. This is a regional custom, and its purpose was very practical, as it was intended to hide scuff marks on the bottom of the door. Guest rooms in the Palace were most likely more spacious than in the other older hotels in the village. There was the typical bed along with a dresser, night stand, and several chairs. Both interior photographs date from 1921. In later years, the Palace was known as the Community House. (Photographs courtesy of the Village of Montgomery Museum.)

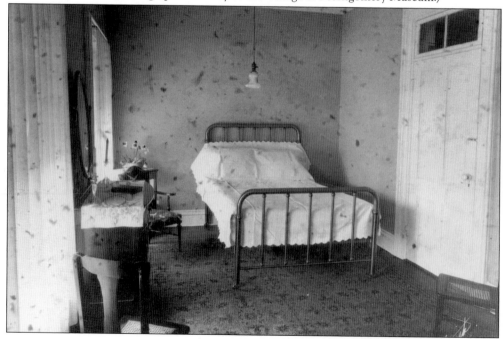

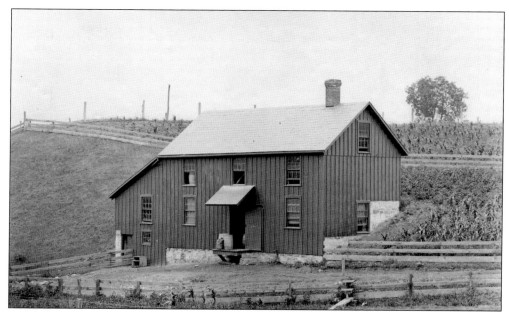

On the hill sloping down from the railroad tracks to the rear of Kaufmann's garage stood John Eager's tannery. A late-19th-century advertisement notes, "Hides and Skins Tanned for Rugs and Robes." The interior photograph below shows the operation at work. Notice the bottles on the ledge of the foundation; these served as the old-time fire extinguishers. They would be grabbed by the neck and hurled at the fire, and the bottle would break, dispersing its liquid contents. This building has long since disappeared from everyone's memory, but a portion of its foundation, along with the adjacent ruin of an old creamery, survive to this day. (Photographs courtesy of Robert L. Williams, Crabtree collection.)

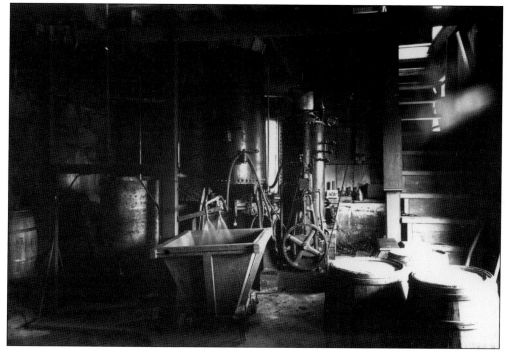

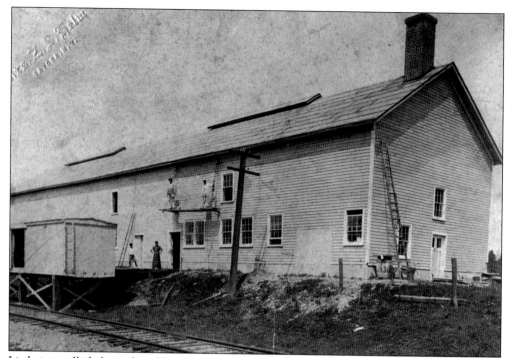

Little is recalled about this old creamery other than it stood along the west side of the railroad tracks a short distance north of Route 17K. It was a large building that has long since disappeared. Skip Chambers seems to recall that the building burned. It was located along the railroad tracks in order to load the milk cans on the train. Today many pieces of broken milk bottles can be found in this area. (Photograph courtesy of Skip Chambers.)

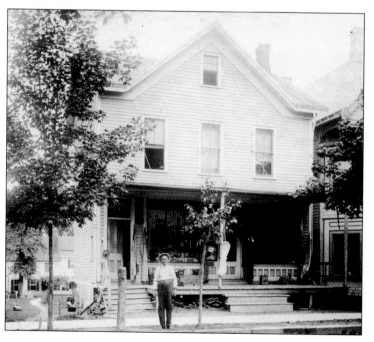

Thomas Chambers had his harness and saddle shop on Clinton Street next to the old Methodist church. This c. 1905 photograph shows the business in its heyday. Unfortunately, little seems to be remembered about this pursuit other than it was founded by Skip Chamber's great-grandfather in 1865. (Photograph courtesy of Skip Chambers.)

Thomas's son John built his horse stable on the corner of Ward and Spring Streets in Montgomery at the beginning of the 20th century. Originally there was room for 22 horses in the building, most of which were work horses that were sold to area farmers. On the left side of the building was an office, which is still in use today. The stone garage across the street was built about 1910. (Photograph courtesy of Skip Chambers.)

The back portion of the red barn across the street dates from the 19th century and originally stood where the firehouse is today. It was moved to the current location due to the slope of the hill to allow use of the basement level. The front portion, built about 1930, was used for horses, while the back half was used for hay storage. The lower level was used for cattle. (Photograph courtesy of Skip Chambers.)

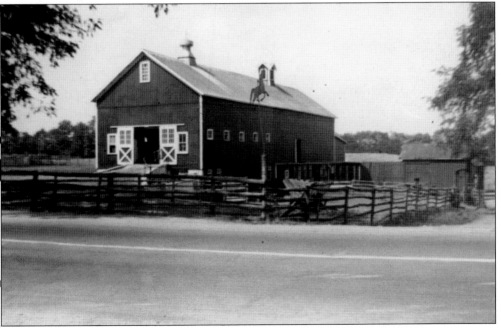

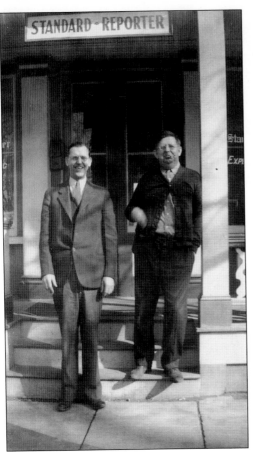

The *Standard and Reporter* was Montgomery's local newspaper for many years, chronicling village events and the lives of its residents. It was located in the building on the northeast corner of Clinton and Bridge Streets. Seen here is its publisher, Dan Taft, standing to the right. The village has a long history of newspaper printing. (Photograph courtesy of Robert L. Williams.)

Puff's Ice Cream Parlor stood on the northeast corner of Clinton and Union Streets and was a favorite place for the nearby schoolchildren at the beginning of the 20th century. The old Victorian-era building still survives but has been greatly altered from its original appearance. (Photograph courtesy of Barbara Conroy.)

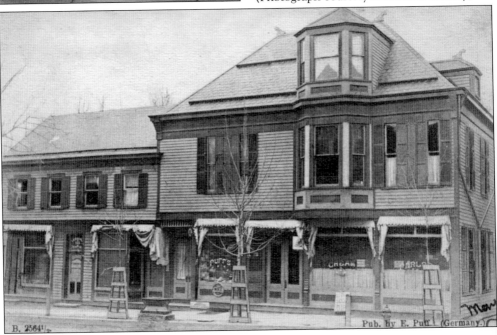

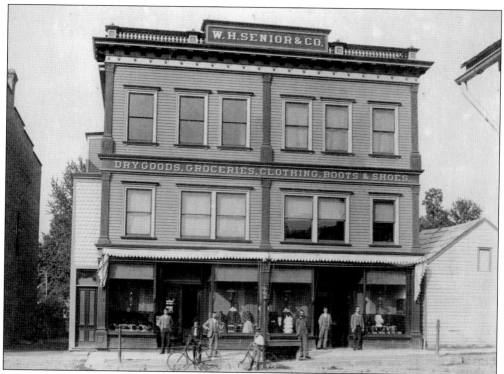

William Senior's store stood on Clinton Street, opposite the site of the former post office. It was the department store of its day, offering dry goods, groceries, clothing, shoes, and much more. Many of the old-time Montgomery postcards were sold from this store. A movie theater was located on one of the upper floors. Interior walls of the storeroom were trimmed in wainscoting coated in a natural finish. In later years, the building had a fire, and the top two floors were removed, leaving only the first floor, which survives to this day. Both photographs date from the beginning of the 20th century. (Photographs courtesy of the Village of Montgomery Museum.)

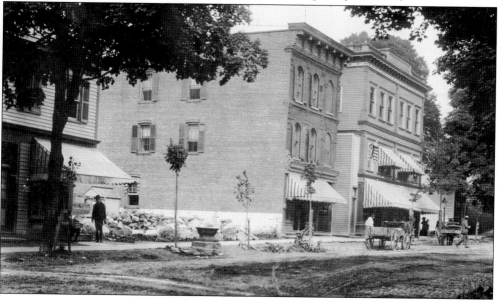

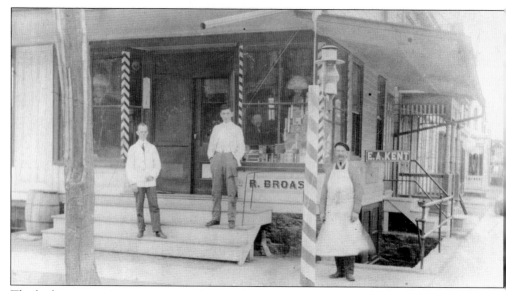

The barber was an important part of village life years ago. R. Broas's barbershop is shown here when it was located on the west corner of Clinton and Union Streets, where Walden Savings is today, at the beginning of the 20th century. The old building was known as the Military Hall, and the Orange Hussars were reputed to have drilled on the second floor of the building years earlier. Around 1900, the interior of the barbershop was trimmed in wainscoting and decorative shelving. Years later, Broas occupied a small building to the east on the opposite side of Clinton Street. Phil DeLessio now occupies the shop. Phil recently donated a small portion of the shelving unit seen below along with the old-time barber mugs, each having painted thereon the name of the person to whom it belonged to at the beginning of the 20th century. (Photographs courtesy of Robert L. Williams.)

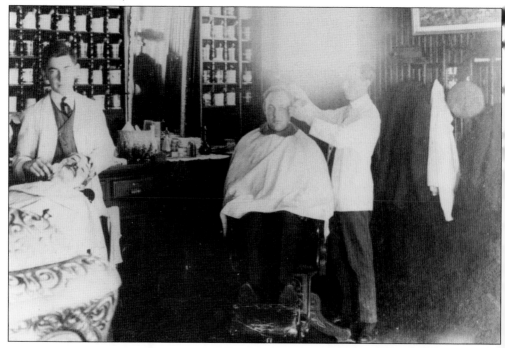

Once the old building was moved to its current location (it was originally located at the corner of Union and Clinton Streets) to make way for the bank, it was occupied by Edward Devitt, who settled in the village around 1910 from New City. Here he established his Montgomery Model Bakery, which became the delight of many residents. Note Broas's barbershop next door. Devitt's Bakery is today the home of Ed's (Benson) Deli. (Photograph courtesy of the Village of Montgomery Museum.)

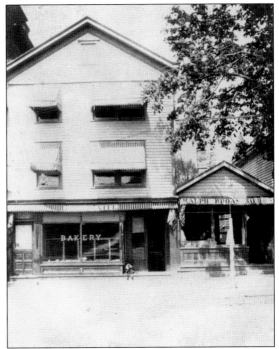

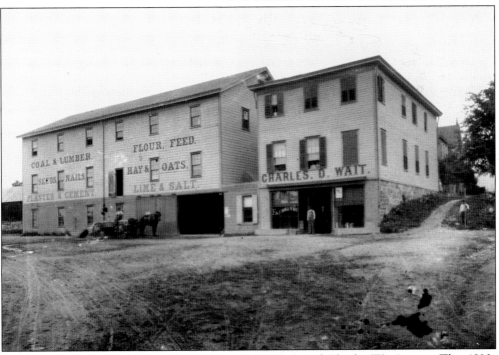

On the corner of Clinton Street and Railroad Avenue stood Charles Wait's store. This 1890s photograph shows the two buildings as they originally appeared. Many of the supplies used to build and remodel area homes were purchased by Chauncey Brooks from this business. A railroad spur extended into the south end of the left building. Both buildings survive and are primarily used as rental units. (Photograph courtesy of Robert L. Williams.)

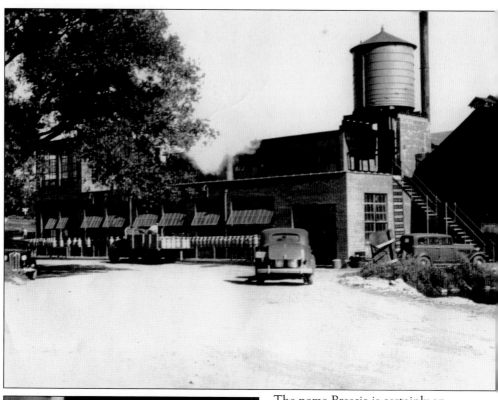

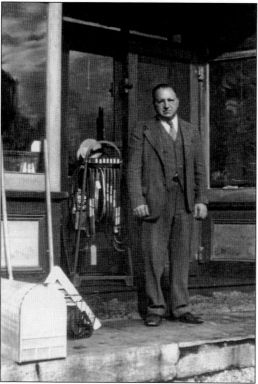

The name Brescia is certainly an indelible one in the 20th-century history of Montgomery village. Vincenzo Brescia, an Italian immigrant, with the assistance of his young son, Louis, began a junk business in 1908. It must have proved profitable, as in 1914, these business-minded individuals started a cheese factory and later purchased a milk business, both of which were combined into a creamery known as the Brescia Milk Company. It was located on Boyd Street. (Photograph courtesy of the Brescia family.)

In the winter of 1929, the junk business began to slow down, so Louis Brescia began drawing coal from the train wreck at Clark's Crossing and created Brescia Coal, Feed, and Lumber, which stood along Railroad Avenue, where the ProBuild Liquidation Center is today. This 1930s photograph of Louis was taken on the doorstep of his old hardware store building. (Photograph courtesy of the Brescia family.)

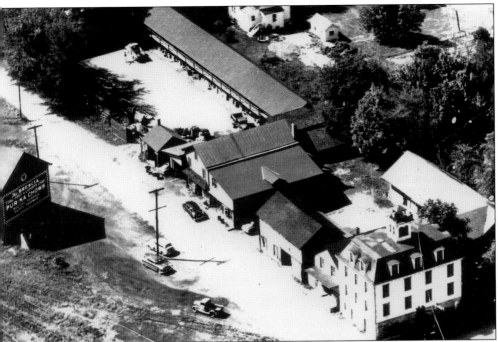

For years, the Brescia lumberyard was a vital part of the community, and nearly all village residents were touched by the operation and family in one way or another. In 1970, Louis's two children, Vince and Rose Marie, started a business in conjunction with the lumber operation called Lo-Bre Homes (named after their father), in which they built economical homes for the community. In the 1970s, the lumberyard was updated and expanded with newer buildings, replacing some of the earlier structures. The above aerial photograph dates from the 1940s, while the lower photograph, showing the old hardware store, dates from about 1970. (Photographs courtesy of the Brescia family.)

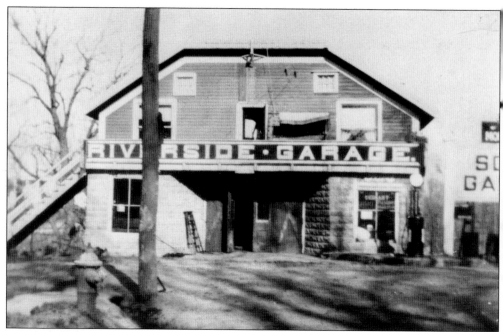

Another old-time business in the village was William Hall's Riverside Garage, which stood along Ward Street diagonally opposite Union Street. Established in 1912, the building originally served as Comfort's Hardware, and Hall significantly expanded the building to house his operation. He has the distinction of being the first one to establish a Ford dealership in Orange County. The picture below shows his old wrecker. William's daughter, the late Agnes Karsten, recalled the story of when her father towed a car involved in a nearby car wreck back to the shop. It was registered to none other than Eleanor Roosevelt. Apparently, the car was stolen by a chauffeur and ran into the back of a truck near Bodine's Bridge, and he and his passengers were killed. (Photographs courtesy of Caroline Henrie.)

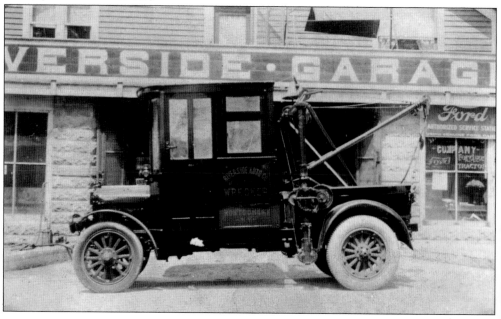

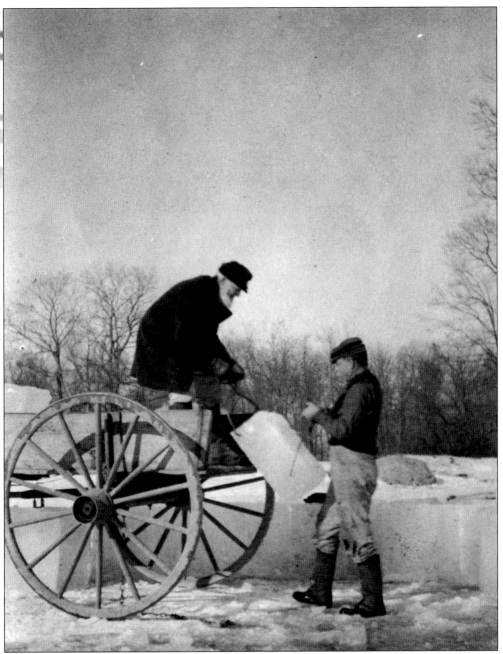

A common winter activity was ice harvesting in order to replenish the supply in area icehouses. In the days before electric refrigerators and freezers, it was vital to have ice in the household. Here Mr. Brown and Jim cutting ice on the Wallkill River about 1910. The ice would then be carted to the icehouse, where it would be stored partially underground within straw or sawdust. The last surviving icehouse in the village was at the Crabtree Mill. It collapsed in 2009, and only its deep cellar hole survives. (Photograph courtesy of Robert L. Williams, Crabtree collection.)

One of the most popular businesses in Montgomery at the beginning of the 20th century was Brown Brothers, a hardware store that stood on Fought Street between Clinton and Ward Streets. For many years, a tin kettle hung in front of the store on which was painted "Brown Bros. Hardware." The old sign can today be found on display at the firemen's museum. The store seemed to stock nearly everything and would provide the materials for many of the standing-seam tin roofs that were once popular. This photograph dates from the 1950s. (Photograph courtesy of the Village of Montgomery Museum.)

Seven

RECREATION

Life was surely challenging in the early days with the struggles to survive without the many modern conveniences taken for granted today. The Wallkill River remains a major resource for the village, not only for industry, but for the many recreational activities associated with water. This late-19th-century postcard shows a small boathouse west of the bridge. (Photograph courtesy of Robert L. Williams.)

Stratton's Dam along the Wallkill River created a lake setting extending beyond the Wallkill River Bridge from where this photograph was taken about 1905. Stratton's Mill was located opposite the beginning of Union Street, a short distance to the east. It fell into ruins early in the 20th century, but parts of its foundation can still be found collapsed in the riverbed. The wall to the right of the photograph was located behind D. A. Shafer's Wallkill Hotel, a favorite stay-over for area travelers where rowboats were available, as seen in this photograph. Virginia Shafer Donnelly, D. A.'s daughter, recalled an inadvertent dunking she experienced in the river at the age of five (in 1909) when her cousins were swinging her in the hammock adjacent to the Wallkill. All

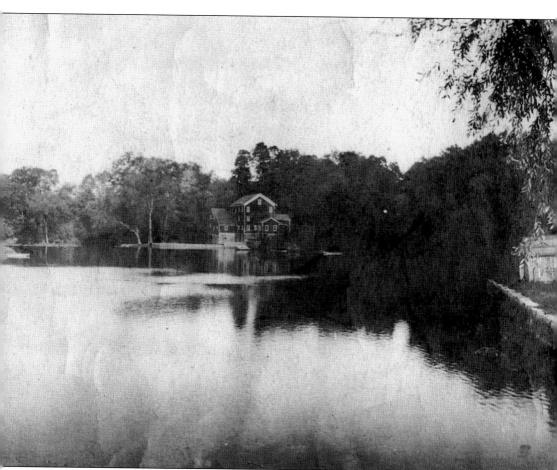

of a sudden, young Virginia went flying into the river, and had it not been for bartender Julius Huber, she may well have drowned. When asked what she recalled about the event, she wittily said "seeing fishes." The tree-covered hill on the left side of the photograph contains the Greek Revival–style residence of Daniel Waring, which later became the home of his daughter and son-in-law, Mr. and Mrs. Thomas Stratton. Built in 1844, it is thought that the rear section of the home may incorporate the remnants of Jacob Crist's pioneer home. (Photograph courtesy of Robert L. Williams.)

Dan Shafer was well known for the clambakes he held on the grounds behind his Wallkill Hotel on Ward Street. At the bake held on the Fourth of July in 1892 were other events to draw patrons, including a boat race on the Wallkill River, tub race, and greased-pig contest. St. Andrews' Band was engaged for the day, and in the evening, there was dancing at the open dance pavilion overlooking the Wallkill River. Patrons would make a sport of trying to skip the clamshells across the Kill. After the hotel changed hands, the bakes were held by other concerns. The clambake shown above was held on the side lawn of the former Palace about 1920. (Photograph courtesy of the Village of Montgomery Museum.)

In the winter months, skating was a popular sport on the Wallkill River, and the two primary areas enjoyed by local residents were those above Crabtree and Stratton Dams. Both views date from the 1890s and were taken in the area above Crabtree Dam. The house in the background of the above photograph stood along River Road on the west side of the Wallkill River and was removed years ago; a modern house now stands at the site. Lemma Crabtree recalled that her uncle Charlie had the job to ensure the ice above the dam was thick enough to support skating. (Photographs courtesy of Robert L. Williams, Crabtree collection.)

Fishing in the Wallkill River was also a favorite pastime, and one of the premier spots was a short distance above Crabtree Dam behind what is today River's Edge Apartments along Factory Street. Lemma Crabtree recalled the time of a chemical spill from one of the mills upriver, which resulted in bushels of dead fish at the Crabtree Dam. Her uncle had the nasty job of removing them. (Photograph courtesy of Robert L. Williams, Crabtree collection.)

This image shows William Crabtree taking a break on what was undoubtedly a hot summer day in 1898. William's son, John, noted to his daughter, Lemma, that William was not one for wading in the water, but did so for the benefit of the photograph. The photograph was taken at the railroad overpass a short distance east of Factory Street. This bridge was replaced by the current bridge in 1912. (Photograph courtesy of Robert L. Williams, Crabtree collection.)

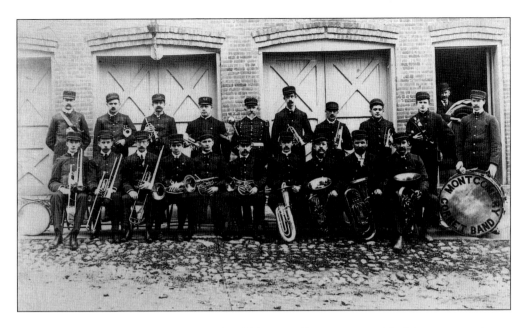

Small bands were an important part of local life in small communities like Montgomery. Annie Shafer recorded in her 1878 diary that she attended singing school and local concerts with her beau. The above view shows the Montgomery Cornet Band, made up of members of the fire department. This photograph was taken around the beginning of the 20th century in front of the brick firehouse, destined to be destroyed by the Great Fire of 1913. The lower view of the Killworth Mills Band dates from 1890 and features the Crabtree brothers—from left to right, Charles, Harry, William, and John. This band also included mill workers. It is suspected that William Crabtree Sr., who began his textile career in Foster's Black Dyke Mills in Queensbury, England, was somewhat copying his former employer's more famous Black Dyke Mills Band, which survives to this day. (Photographs courtesy of Robert L. Williams, Crabtree collection.)

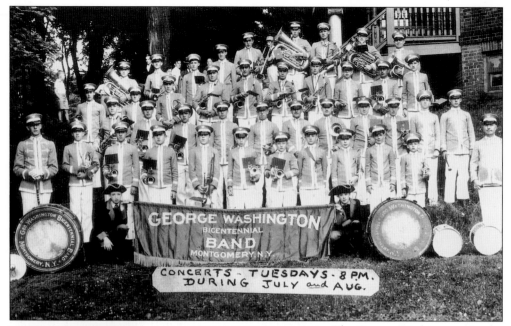

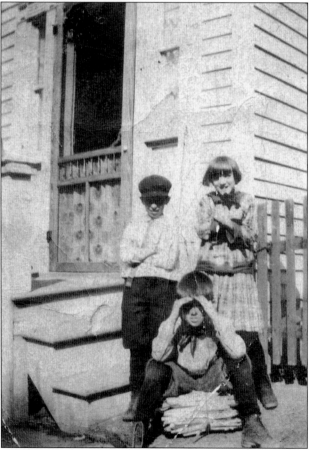

The George Washington Band was established by William Hall in 1932 to commemorate the 200th anniversary of George Washington's birth. Hall, who ran Hall's Garage on Ward Street opposite Union Street, was a very civic-minded person and well loved. He led band concerts every Tuesday night for almost 30 years. One or two village residents survive today who were members of this band. (Photograph courtesy of Robert L. Williams.)

Although children were kept busily engaged with the many chores bestowed upon them by their parents, there was always time to gather and play. Shown here are Thomas Taft, Virginia Shafer, and Marco Santoro (seated) in front of the Taft House on Bridge Street about 1911. The house has since been moved to 42 Elizabeth Street. (Photograph courtesy of Robert L. Williams.)

Founded in 1910 by Chicago publisher William Boyce, the Boy Scouts of America is today one of the largest youth organizations in the United States, with over four million youth members in its age-related divisions. Its goal is to train youth in responsible citizenship, character development, and self-reliance through participation in a wide range of outdoor activities and educational programs. What is believed to be the local scout group around 1914 is seen above in front of the Hadaway residence at 67 Union Street. The photograph at right is of William Hadaway taken in the north bedroom of the aforementioned house. Interestingly enough, the above photograph can be seen hanging on the wall to the right of William. Girls also had an organization in Montgomery that was popular in the early years of the 20th century: the Campfire Girls, formed around 1917. (Photographs courtesy of Robert L. Williams.)

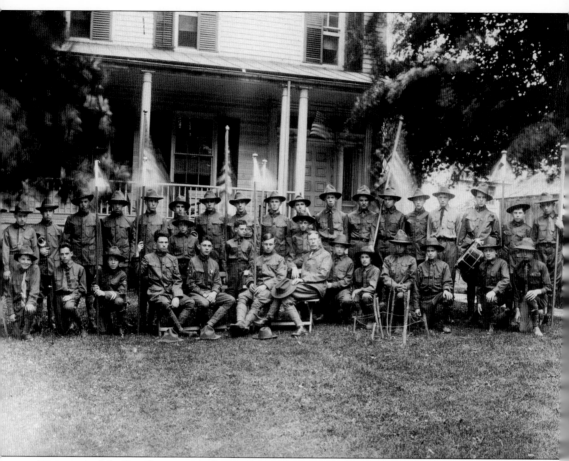

This view of the Boy Scouts was taken in front of the Hanlon House on Clinton Street, otherwise known as the Borland House, after its original occupants. It is one of the premier Greek Revival–era buildings in the village. It is believed to date from 1912 to 1914. Everyone in the photograph is in full dress uniform. (Photograph courtesy of Robert L. Williams.)

Bicycles seem to have come into their prime during the Victorian era, and it was not uncommon in the cities and countryside alike to see both men and women in groups or bicycle parties. These views of bicycles were taken at the Hadaway House at 67 Union Street around 1912 and were an important part of everyday life for the Hadaway boys. During the Hadaway auction in the fall of 1989, one of the items sold was a small nickel-plated kerosene lamp, which once adorned the front of a bike, perhaps one of those shown in these photographs. The lamp is displayed today in a cupboard of the Hadaway residence by the current owner. (Photographs courtesy of Robert L. Williams.)

Here is Wilmot Chambers with son Skip in the early 1940s on the Chambers property, where tractors are currently displayed. The old house in the background stood at 159 Ward Street and has since been demolished. It was believed to date from the Greek Revival era. (Photograph courtesy of Skip Chambers.)

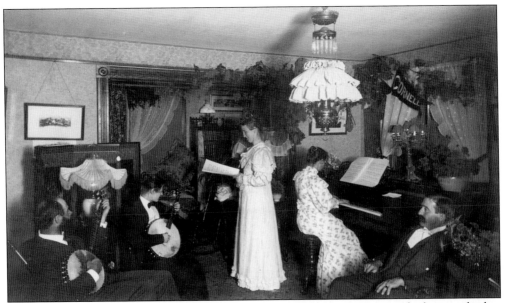

In the days long before television, people created their own entertainment in the home, whether it was reading, looking at stereo cards through a viewer, or playing games. Here the Senior family is pictured in their home on Prospect Terrace singing and playing piano and banjos. (Photograph courtesy of Robert L. Williams.)

Madeline Shafer Earle recalled how the family Christmas at the beginning of the 20th century consisted of a Christmas tree with real candles that were lit on Christmas morning and how the stockings were hung from the mantel in her parents' bedroom. The stockings were stuffed with such things as oranges or a banana. Here is the Hadaway Christmas tree at their home at 67 Union Street about 1912. (Photograph courtesy of Robert L. Williams.)

One of the centerpieces for entertainment in the community was the old bandstand that once stood on the front lawn of the Presbyterian church on Clinton Street. Shortly after the beginning of the 20th century, it was replaced with a more stylish structure with a domed roof. It was later moved to the other side of the old academy building and from there to the Veterans' Park, where it was destroyed in a wind storm. (Photograph courtesy of Robert L. Williams.)

PRESBYTERIAN CHURCH PARK AND BAND STAND.
MONTGOMERY, N. Y.

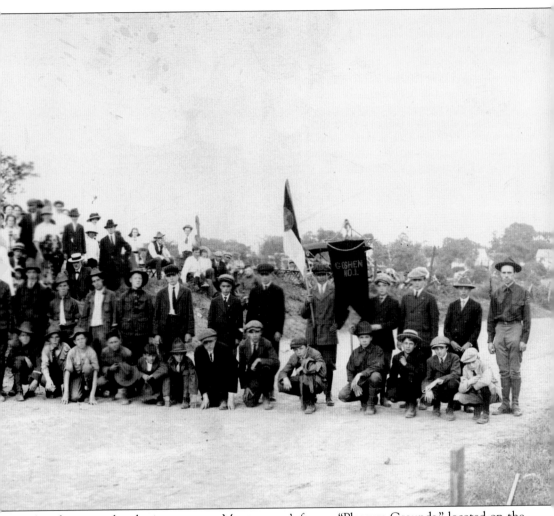

Another central gathering spot was Montgomery's former "Pleasure Grounds," located on the south side of Bachelor Street. Here there was a racetrack used for Standardbred racing, and the site was used for some of the early Orange County Fairs (1850 and later). It is noted that horses were raced or trained here until World War I. The village has set this land aside for active and passive recreation. It is noted that where the boat launch is today was the site once used by skinny dippers. This photograph, which shows a portion of the track, dates from about 1912 and features some of the Goshen Boy Scouts, who were gathering with the Montgomery contingent. (Photograph courtesy of Robert L. Williams.)

Eight

TRANSPORTATION

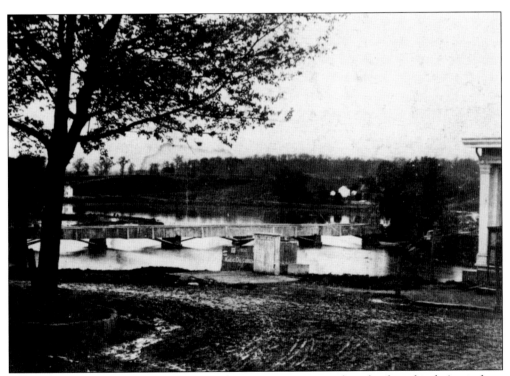

When the first settlers came to the area, there were no improved roads of any kind. A trip from Montgomery to the Newburgh waterfront could take a day. Many of the waterways initially had fording spots, which would later be replaced with bridges. Here is the earliest photograph of Ward's Bridge, taken from the corner of Union Street about 1870. (Photograph courtesy of Robert L. Williams.)

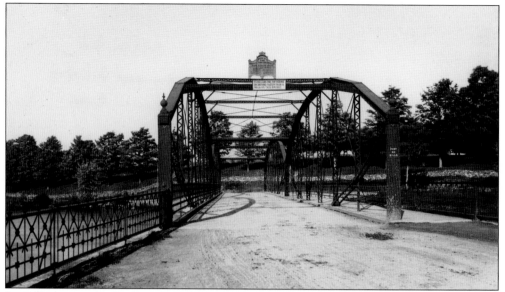

In 1887, the wooden bridge was replaced with this decorative iron bridge manufactured by the Berlin Iron Bridge Company of East Berlin, Connecticut. This, in turn, was replaced by the current bridge in the middle of the 20th century. Charlie Shafer recalled a funeral where attendees got drunk, and on the way to the cemetery, the corpse was set up at the corner, where he was toasted by the attendees. (Photograph courtesy of Robert L. Williams, Crabtree collection.)

Early in the 19th century, turnpikes became all the rage and were funded by private investors hoping to see a return on their investment from the tollgates that were established at various locations. These road systems provided more direct routes and an improved surface. The village would become host to two such roads: the Minisink and Montgomery Turnpike, now Route 211, and the Newburgh and Cochecton Turnpike, now Route 17K. (Photograph courtesy of Robert L. Williams, Crabtree collection.)

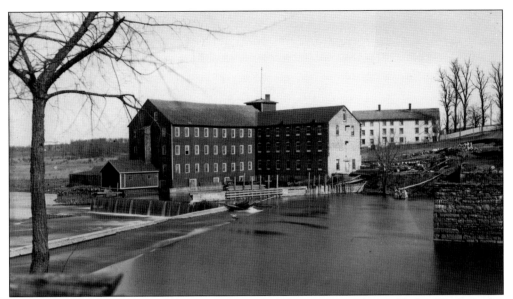

Early in its history, the village contained two bridges that traversed the Wallkill—Ward's Bridge and Copley's Bridge. Copley's Bridge was constructed around 1818 at Factory Street through a cooperative undertaking by farmers living on the east side of the river. On the morning of March 18, 1862, half of the bridge went down, and it was never rebuilt. The bridge piers are seen on the right side of the photograph. (Photograph courtesy of Robert L. Williams, Crabtree collection.)

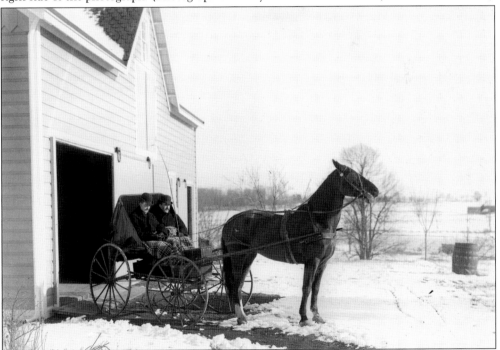

For many years, the only modes of transportation were horse, horse and wagon, or one's own two feet. Brothers Ed and Will Crabtree are seen in front of their father's carriage house on Factory Street around the end of the 19th century. The old carriage house was removed in 1994, after its roof collapsed. (Photograph courtesy of Robert L. Williams, Crabtree collection.)

Back in the old days in the winter months, there was no department of public works to clear the roads, and at times of heavy snowfall and drifting such as the Great Blizzard of 1888, the area was left paralyzed for several days. Some roads such as Factory Street, seen here around the end of the 19th century, were cleared by horse-drawn plow. (Photograph courtesy of Robert L. Williams, Crabtree collection.)

The next major improvement in transportation was the railroad. Not long after the Civil War, a rail line connecting the village of Montgomery to Goshen was constructed. Shortly thereafter, the line was extended to Walden and then beyond to Kingston. This turn-of-the-century Crabtree photograph shows the line extending from Factory Street eastward. Route 17K is seen in the distance, as well as the old Fowler farm. (Photograph courtesy of Robert L. Williams, Crabtree collection.)

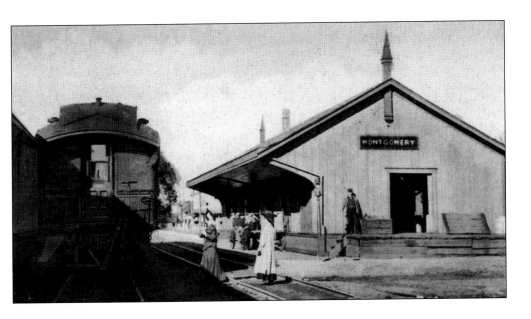

Montgomery's Union Station stood along Railroad Avenue nearly opposite Charles Street and was built around 1870 on property currently used by Chambers. After passenger service ceased in the 1930s, this venerable old building fell into disuse, and it was destroyed by the fire department in 1971. Adjacent to the old station was the turntable where locomotives could be turned around in order to head back in the opposite direction. Some of the workers who built the rail line, like Chauncey Brooks, would make Montgomery their permanent home. The new line also made the area a summer tourist destination for city folks, and many area homes would take in boarders. (Photographs courtesy of Robert L. Williams.)

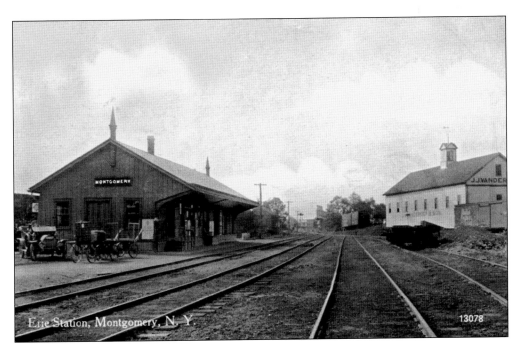

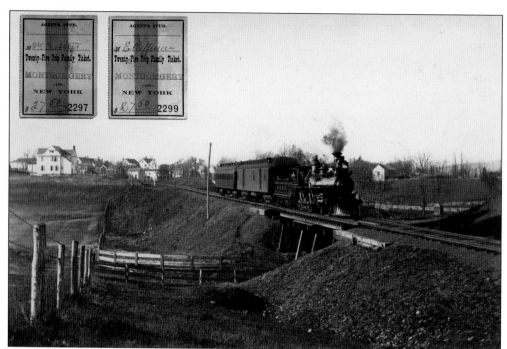

The train seen here is on its way from Montgomery to Walden in 1895. This view was taken between Ward and Factory Streets, and the locomotive is seen crossing Hallet's cattle pass. The old pass was eliminated many years ago. The railroad provided quick transportation and rapidly became a fixture of everyday life. A trip from Montgomery to New York cost $1.10 around 1900. (Photograph courtesy of Robert L. Williams, Crabtree collection.)

The one mode of transportation that would bring the greatest change to Montgomery, and areas like it, was the automobile. At first they were the toys of the privileged, but eventually they would become affordable to the masses and would bring the outside world closer to home. This c. 1920 view shows John A. Crabtree's new car and garage behind his home on Factory Street. (Photograph courtesy of Robert L. Williams, Crabtree collection.)

Nine

MONTGOMERY OF THE RECENT PAST

On August 5, 1940, the Village of Montgomery purchased property on Prospect Terrace from George E. and Grace Gridley. On January 7, 1941, the board put forth a bond resolution for the construction of a water tower, and to this day, it continues to provide much of the village's water storage. The water tower was featured in the 2006 film *The Night Listener*, starring Robin Williams and Toni Collette. (Photograph courtesy of Veronica Rickerd.)

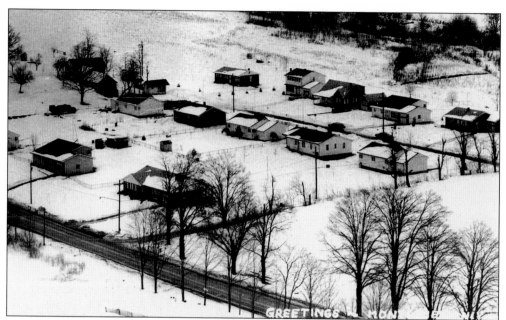

This aerial photograph taken in the 1960s shows portions of Union Street, Chandler Lane, and Frieda Street. Notice that Viking Heights is nonexistent, as it was developed in the 1970s, and Bricktown Manor was built in the late 1980s. The village population at the time of this picture was about one quarter of what it is today. (Photograph courtesy of Robert L. Williams.)

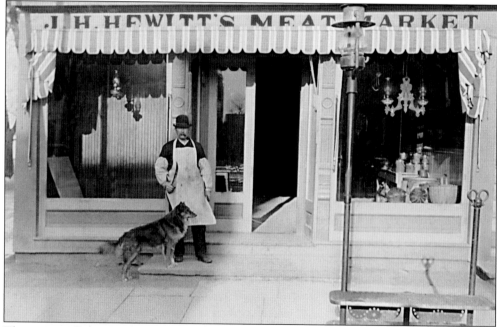

This picture illustrates the J. H. Hewitt Meat Market, which was in business around the late 1800s to the mid-1950s. The present building now houses the Wildfire Grill. J. H. Hewitt lived in the house to the left of the Hadaway House on Union Street, and he was the great-grandfather of Karen Hoeffner. Notice the step where carriages pulled up to allow individuals to disembark. (Photograph courtesy of Karen Hoeffner.)

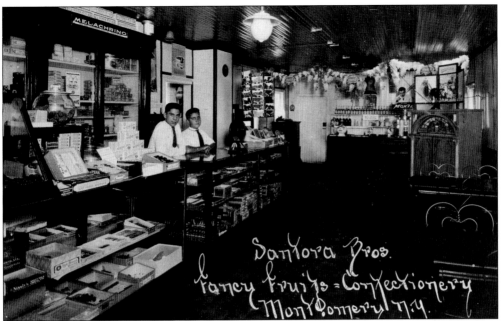

The Santoro family was a prominent business family that sold confectionaries, tobacco, and ice cream in the western side of their store (shown above) and produce in the eastern portion. This Clinton Street business was often a gathering place that villagers thoroughly enjoyed, especially for clambakes. The operation began in the mid-1920s and ceased in 1945. The eastern side was converted to a tavern and restaurant in the late 1930s. Proud owner Anthony Santoro (below) ran Tony's Bar and Grill until the mid-1940s. It was a sad day in Montgomery when Santoro's closed its doors and moved some of its operations to Cornwall. Many taverns and restaurants emerged in subsequent years, such as Bayards, Chase's, Clara's, and King's. Eventually Copperfields burst onto the local scene in 1986 under current owner Dan Purcell (later Paul Satkowski joined the business). (Photographs courtesy of Mary Havens.)

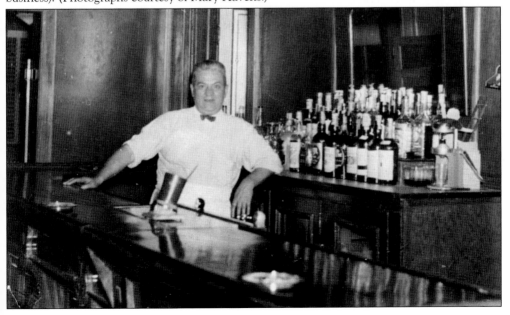

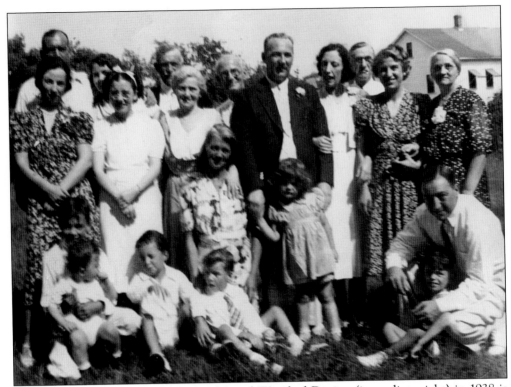

The wedding of Thomas (black tuxedo) and Winifred Devine (immediate right) in 1938 is celebrated with many of the Devine family children, cousins, and extended family. Pictured with the Devines are best friends Louis Brescia (kneeling), Violet Brescia (second from right), and a young Vincent Brescia (sitting bottom right). Thomas Devine was a chemist who grew up on Union Street. (Photograph courtesy of Joe and Carol Devine.)

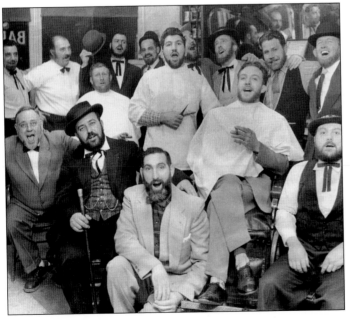

Pictured in Phil DeLessio's newly-opened barbershop, these gentlemen, from left to right, showed off their whiskers for the beard contest: (first row) Ray Sechrist, Mike LaRusso, John Mills, and Bill Fostner; (second row) Jan Glorie, Phil DeLessio, and Ted Schmidt (in barber's chair); (third row) Phil Martini, Adam Sweikata, Vince Brescia, George Badalucco, Earl Monroe, Jerry Miller, John "Hap" Schmidt, and Ed Broas. DeLessio celebrated 50 years in business in October 2008. (Photograph courtesy of Phil DeLessio.)

This 1940s photograph shows Joan Chambers on the spotted pony and Skip Chambers on horseback. Joan and sister Nancy (not shown) were renowned equestriennes, each winning the title of Queen of the Rodeo at Madison Square Garden among nearly 200 competitors. Joan won the honor in 1952 with Roy Rogers as the main star of the weeklong rodeo, and Nancy won in 1954 with Gene Autry being the guest star. (Photograph courtesy of Skip Chambers.)

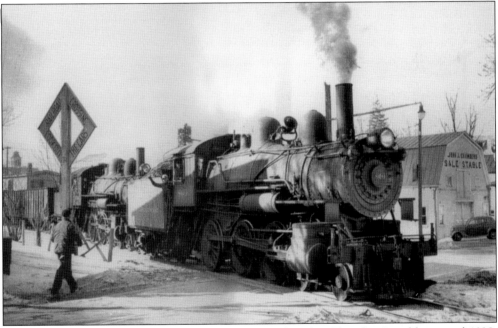

This vintage photograph shows a northbound train by John Chambers's stable around 1938. Freight trains were going strong from Campbell Hall to Kingston. Chambers, at the time of this photograph, was selling horses and cattle to local farms. Tractor sales did not become part of the family business until Skip Chambers introduced the new machinery in the 1950s. It has remained one of the top dealers in New York. (Photograph courtesy of Skip Chambers.)

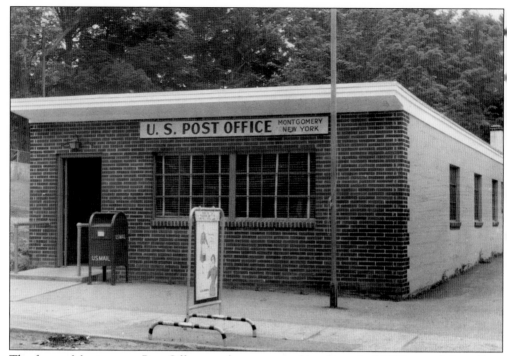

The former Montgomery Post Office, newly constructed by the end of 1957, served the village until 2002, when the site was purchased by the Village of Montgomery. After the village purchased the property, the building was subsequently torn down, and the Montgomery Post Office moved to its present location on Boyd Street. A landscaped green area and permanent bandstand are planned for the former site. (Photograph courtesy of Jim and Johanna Sweikata.)

This building was built by the Van Dyke family in 1949 as a trucking terminal and repair garage. Paul Teutul Sr., of Orange County Choppers fame, rented the building for approximately 10 years as a welding shop, and the building was then bought by Mario Balacich in 1985. Eighty-Eight Charles Café opened for business in 1986 and continues to be one of the finest restaurants in the area. (Photograph courtesy of Mary Van Dyke.)

Another satisfied customer fills up and gets an oil check at Kaufmann's Esso in the late 1950s. Begun in 1953 by Ralph Kaufmann and sons Rodney and Don, Kaufmann's served as the main filling station in the village for more than 50 years. The station changed to Exxon and eventually Gulf in the 21st century. "Bub" Kaufmann was renowned for working long hours and running a tight ship at the family business. (Photograph courtesy Greg Kaufmann.)

This photograph shows Fred Lake hard at work at Kaufmann's Esso around 1960. The Kaufmanns originally started out in business in Brooklyn, New York, and moved the business to Montgomery in 1953. Throughout the latter part of the 20th century, Kaufmann's served as a cornerstone of the village, especially for westbound travelers on Route 17K. (Photograph courtesy of Greg Kaufmann.)

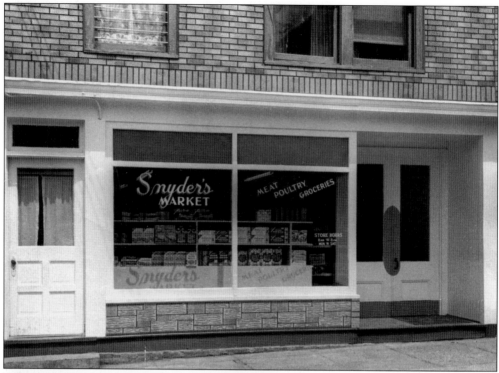

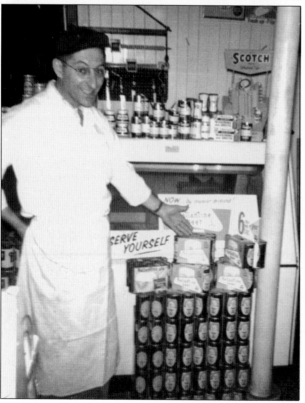

Snyder's Market was an institution in the village from the mid-1950s until the late 1970s. It was regarded as the village meeting place. There was a previous business located at the Grange (on Wallkill Avenue) operated by Charles Snyder, Fred Gorss, and Ray Osterhoudt in the early 1950s. Charles Snyder, in his store at left, was a pillar of the community. He was a butcher, and his store was known for its meats as well as its deliveries morning, noon, and night. Most of a family's grocery needs could be provided by Snyder's. Besides running the store, Charles dedicated his life to the Montgomery Fire Department (in many capacities). Local resident and former Snyder's employee Jim Miller remarked, "Once the siren rang, nobody made it up Clinton Street Hill [to the old firehouse] faster than Charlie Snyder." (Photographs courtesy of Steve and Nina Snyder.)

This picture shows Ed Benson and his daughter, Jai Benson Phillips, in 1982. Ed had his debut in 1979, and the rest is history. Eddie's Deli continues to be one of the most popular meeting places in the village. On an average morning it is not uncommon to see Skip Chambers, Bobby Huff, Gene Froelich, Walt Karsten, Jeff Holtje, Jigger Malley, Jack Hoeffner, Russ Gillespie, Lynne Venetis, and Rags Rosenberg. (Photograph courtesy of Ed Benson.)

This picture shows Bud Wild (welding) and Harry Mack in Bud's Welding Shop on the corner of Wallkill Avenue and Charles Street in the late 1960s. The shop had been Lawson's Blacksmith Shop, and today it has been converted into two apartments. Prior to the conversion, parts of the old blacksmith forges were still visible in the west wall. (Photograph courtesy of Joseph Wild.)

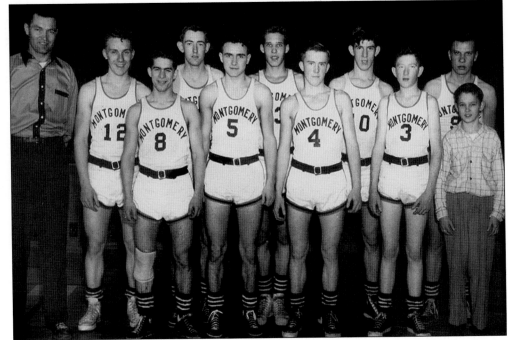

Sports were an integral part of life in Montgomery, whether it was at the high school or in the Montgomery area. The photograph above shows the Montgomery High School basketball team in 1955. From left to right are coach Harold Handchen, Dave Craft, Lou Sclafani, Jim Cunningham, Dick Brader, Dave Schutler, Jerry Miller, Pete Conroy, Charlie Judson, Stan Lorenz, and Jack Zickler (in plain clothes). Below is the Montgomery baseball team that was sponsored by the American Legion. They played other legion teams throughout the county and won the county championship in 1948. Adam Sweikata was the manager, and the team had a great group of players, such as Bob Conroy, Bob Quackenbush, and Bill Fitzgerald. Cooperative sportsmanship was a hallmark of Montgomery. (Above, photograph courtesy of Nancy Dooley; below, photograph courtesy of Jim Sweikata.)

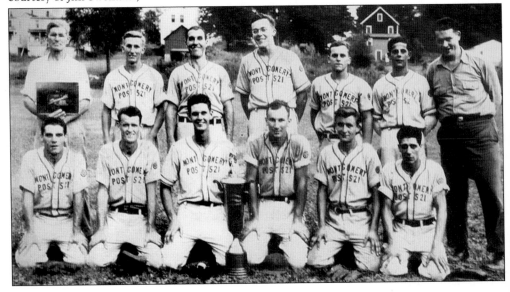

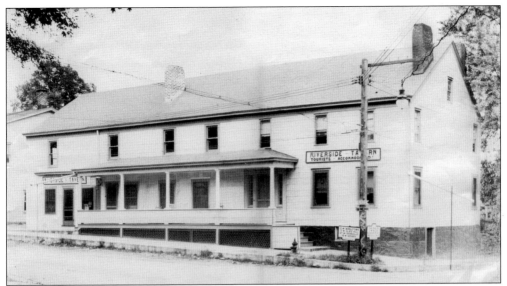

This striking building at the southwest corner of Ward and Union Streets dates from the Greek Revival era. It was a residential property in its early life and served as the Riverside Tavern around the early 1900s. About 1950 and through the 1960s, it was a popular watering hole commonly called the Mission (or Mary's Mission). The Mission was a favorite gathering place of its day, and many recall its long, old-style shuffleboard. (Photograph courtesy of Ed Devitt.)

Here is one of the village's vintage police cars from the late 1960s. The car is being driven in a parade on Union Street with the Montgomery Fire Department pumper truck following behind. Tom Hadaway's house can be seen in the background. The police car was stored in the building behind the old firehouse (the present-day Orange County Firefighters Museum), when the fire department was under the village government. (Photograph courtesy of the Village of Montgomery Museum.)

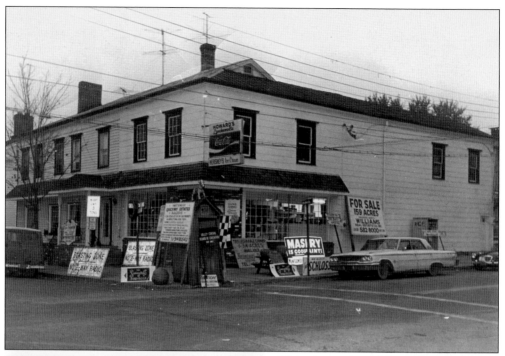

This picture shows Howard's Confectionary and Luncheonette around the late 1960s with the annual Halloween decorations in front. Howard Reis ran his businesses from 1953 to 1972. Howard's was at the heart of the village. Decorating the corner at Halloween was a popular tradition since at least the 1950s. It was harmless fun that was cleaned up in short order. Remarkably, one year an outhouse was situated on top of Rinaldi's Gas Station. (Photograph courtesy of Howard Reis.)

Richard Reynolds, shown here as the General Montgomery Day Grand Marshall in 1997, was one of the most popular village residents of the last half of the 20th century. Called the "Goodwill Ambassador" or "Mayor," Reynolds was often the first person people met when they came to Montgomery. He would walk about the village on his daily trek visiting businesses, the firehouse, and people in general. (Photograph courtesy of the Village of Montgomery Museum.)

General Montgomery Day started in September 1990 and is held annually the first Saturday after Labor Day. Approximately 8,000 spectators attended the first event. Since that time, the celebration has grown to nearly 30,000 every year. One of the main themes of the day is to commemorate Gen. Richard Montgomery (the village's namesake), who was the first general killed in the American Revolution. Historical tours and displays, not to mention some decorated historic homes, add to the flavor that pervades the day. Marc and Brenda Newman (below) have portrayed General Montgomery and Janet Livingston (Mrs. Montgomery) every year since the event's inception. The massive crowd on Clinton Street, shown above, is a testament to the popularity of the day. (Photographs courtesy of Carol Daley and Marc Newman.)

www.arcadiapublishing.com

Discover books about the town where you grew up, the cities where your friends and families live, the town where your parents met, or even that retirement spot you've been dreaming about. Our Web site provides history lovers with exclusive deals, advanced notification about new titles, e-mail alerts of author events, and much more.

Find Your Place in History.